Creative
Watercolor &
Mixed Media

Creative Watercolor & Mixed Media

A STEP-BY-STEP GUIDE TO ACHIEVING STUNNING EFFECTS

Ana Victoria Calderón

PLAY WITH GOUACHE, METALLIC PAINTS, MASKING FLUID, ALCOHOL & MORE!

QUARRY

First Published in 2021 by Quarry Books, an imprint of The Quarto Group,
100 Cummings Center, Suite 265-D, Beverly, MA 01915, USA.
T (978) 282-9590 F (978) 283-2742 QuartoKnows.com

Quarry Books titles are also available at discount for retail, wholesale, promotional, and bulk purchase. For details, contact the Special Sales Manager by email at specialsales@quarto.com or by mail at The Quarto Group, Attn: Special Sales Manager, 100 Cummings Center, Suite 265-D, Beverly, MA 01915, USA.

10 9 8 7 6 5 4 3 2 1

ISBN: 978-1-63159-880-7

Digital edition published in 2020
eISBN: 978-1-63159-881-4

Library of Congress Cataloging-in-Publication Data is available.

Page Layout: Megan Jones Design
Photography: Maureen M. Evans

Printed in China

To all my teachers, guides, and gurus.
I am humbled by all I have left to learn.

CONTENTS

PREFACE

I've never considered myself the type of artist who sticks to one specific brand of paint, or a certain type of paper. Sure, I have my favorites, but I've found that experimenting with all kinds of supplies is at the core of my creative journey. Walking the halls of art supply stores, going home and testing different materials, and being inspired by what a medium has to offer are all special moments for an artist. In fact, experimenting can be the source of inspiration for what can later turn into elaborate pieces. The medium itself becomes the place where ideas are born.

Before writing books and teaching online courses, I taught in-person watercolor workshops. In one of these programs, students would create a large swath of experiments by mixing watercolor in all forms with inks, salt, acetone, and household objects. I never grew tired of seeing the expression on their faces—filled with wonder—amazed at how a simple interaction between these mediums creates pure alchemy. This activity was called Little Planets and it became the staple activity for watercolor workshops and inspired hundreds of students to see beyond what they ever imagined they could do.

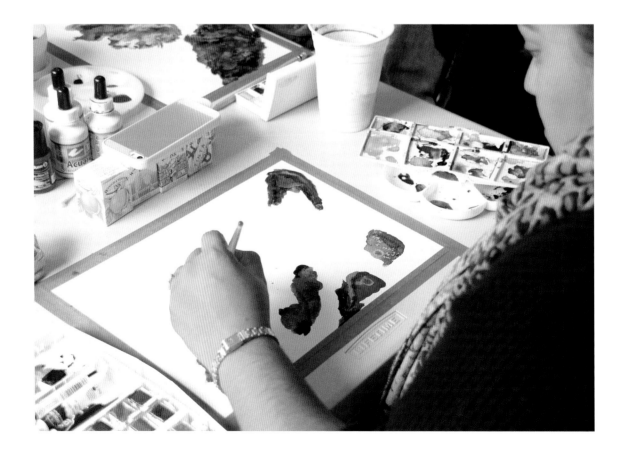

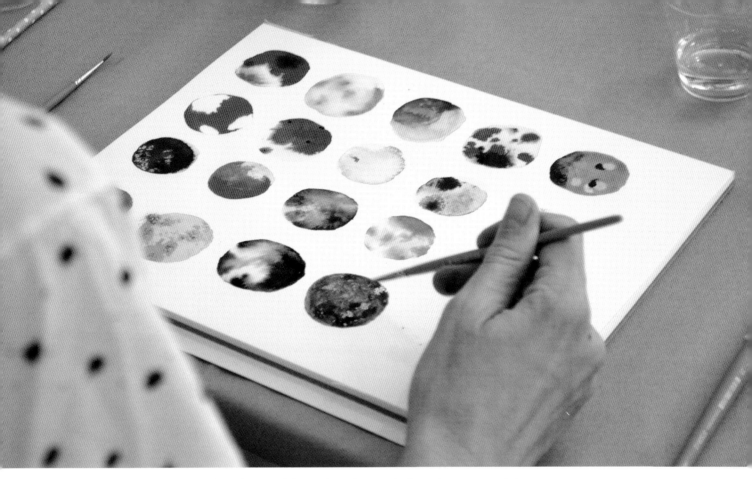

These two photos are examples of some of the work students make in my in-person workshops.

Unexpected effects, surprising textures, and magnificent results came from these experiments. Students went on to see if they could discover any of the circles taking on new form. Maybe this circle could be a jellyfish? Or, maybe it looks like bacteria through a microscope? How about the solar system? Their assignment was to create details to add to these experiments to give them new form. Year by year I was amazed at the ideas they came up with—many of which I never would have thought of myself!

Throughout the years, I've found that many watercolor enthusiasts are interested in the medium, even if they are not sure what they want to create with it. Drawing and painting are two very different things. You don't have to be a gifted hyperrealist artist to appreciate the joys of painting. I've always thought of art as an intuitive process, where the experience is just as, if not more important, than the result.

This book will take you on a path of discovery through experimentation. Drawing prompts are mostly simple geometric shapes that anyone can do, and they leave room to create stunning pieces of art with the alchemy of watercolor and mixed media.

Why Watercolors Are So Great to Mix with Other Mediums

Watercolors are accessible, easy to use with some basic knowledge, and work well with a variety of other mediums. Because the formula is so pure, once activated with water the paints are quite easy to manipulate. Watercolor paints are made from a few simple ingredients—pigment, a binder formula, and water, which eventually evaporates. The pigments and formulas vary depending on the quality of the brand and type of watercolor. In general, watercolor is a great medium to work with because of its simplicity and water solubility. Unlike oil or acrylic paint, watercolor is translucent and blends easily with neighboring colors when applied with enough water. Watercolor is fluid, which means it flows in different directions once applied to paper. The amount of water used, and in this case other mediums, changes the reaction of your wash to create all kinds of textures that activate on their own without much intervention.

The medium offers numerous interesting tricks exclusive to this type of paint—from mixing watercolors with salt, to adding texture with plastic wrap, to applying iridescent effects, to being the foundational layer for opaque paints. You're in for an exciting treat!

A NOTE ABOUT THE PROJECTS

Artists aren't necessarily scientists. While the themes, effects, and projects in this book take many cues from nature, astronomy, and even gemology, the images aren't intended to be accurate or scientific. For this book, creative exploration and artistic expression are what matter most.

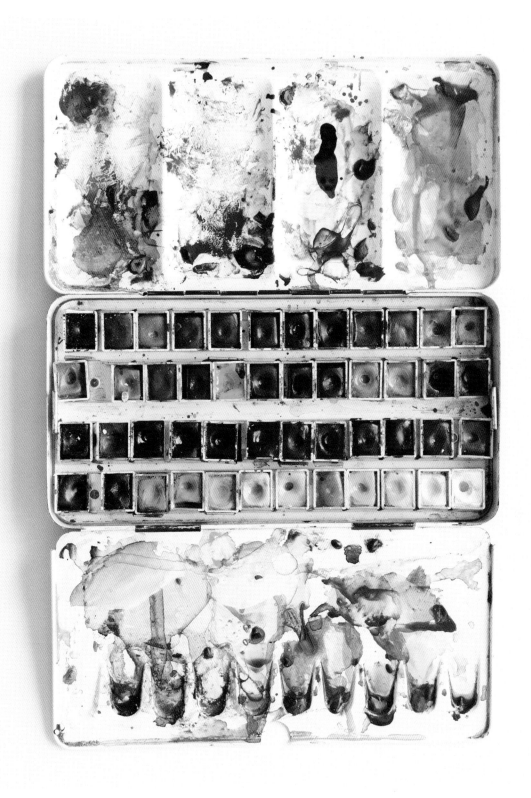

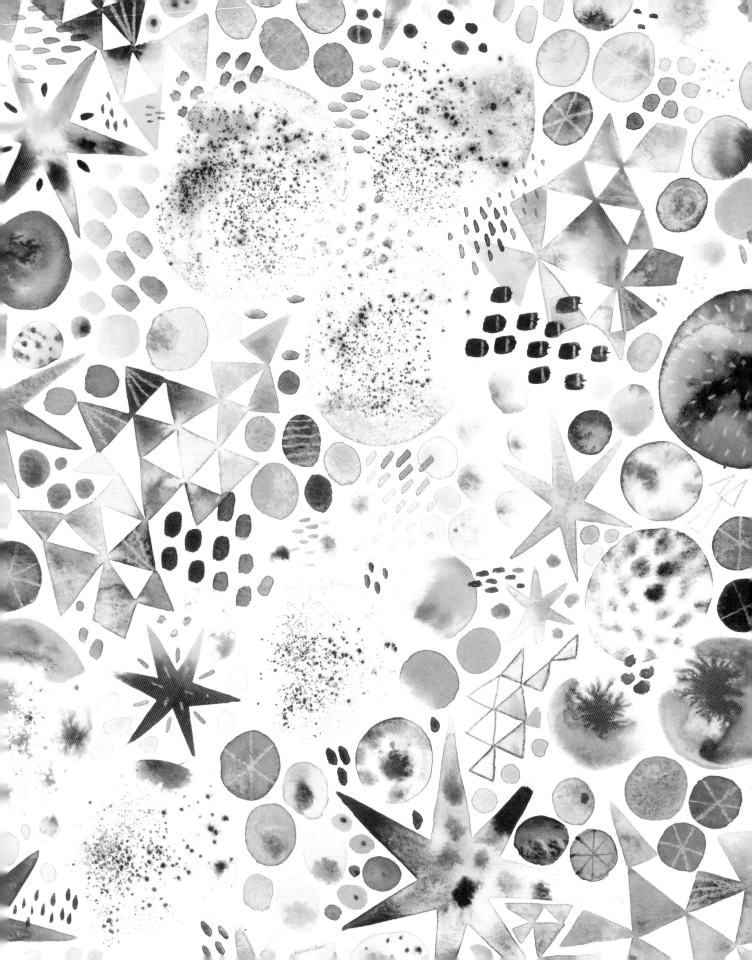

1

MIXED MEDIA: WATERCOLOR & MORE

- - - - - -

In this chapter I share a variety of supplies that you can use for the activities in this book. Because we're working with mixed media as well as watercolor, there are many mediums that are optional or interchangeable. Don't feel as though you need to use the exact supplies I use to achieve magical results; use the paints you have and experiment with what you can. In fact, you probably have most of these supplies around the house already.

WATERCOLOR

As you'll discover in this book, watercolor not only mixes well with other mediums and household supplies, but it's also fantastic at mixing between types and brands of watercolors. In my artistic practice, I usually work with pans, liquids, and tubes, which I mix in a single palette. They're interchangeable and complement each other perfectly.

Some of my favorite brands of watercolor paints are shown opposite.

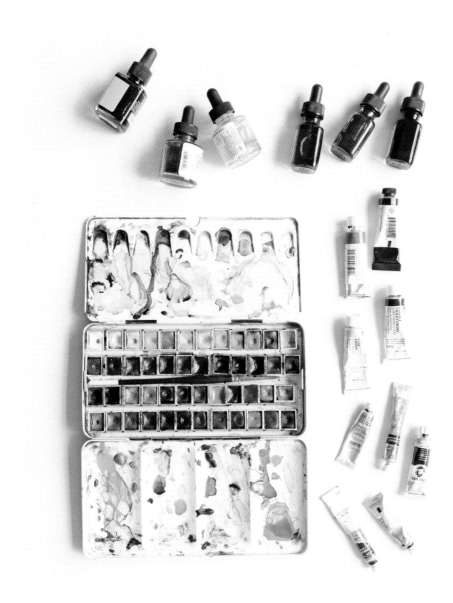

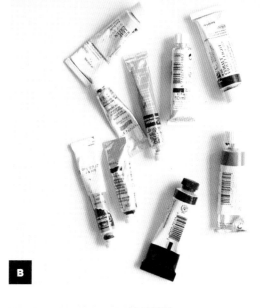

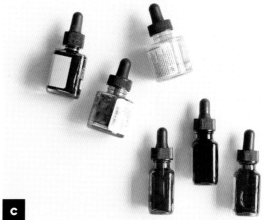

Pans (Watercolor Cakes) (A)

- Kremer
- Schmincke
- Sennelier
- Winsor & Newton
 (Cotman is their affordable
 student-grade line)

Tubes (B)

- Daniel Smith
- Holbein
- Winsor & Newton

Liquids (C)

- Dr. Ph. Martin's
- Ecoline

GOUACHE

Adding Opacity to Translucent Watercolors

Gouache is sometimes referred to as "opaque watercolor," although gouache also shares some properties with acrylic paints because of its thicker consistency and ability to layer from dark to light—something that isn't possible with traditionally translucent watercolors. Gouache paints are also similar to watercolors in many ways, the biggest similarity being that both are watersoluble and reactivate with water. Gouache can also be watered down enough to achieve some sort of transparency or "watercolor look," but it doesn't blend the same way watercolor does. Many artists enjoy gouache as their main medium; it's wonderful in its own way.

A trick I would like to share with you is using a bit of white gouache to mix with your watercolors to achieve a creamy effect with your paints instead of a natural transparency. Adding a bit of white gouache to any color of watercolor paint creates a chalky texture. This is a nice way to add a creamy opacity to watercolors. It's great for creating pastel tones.

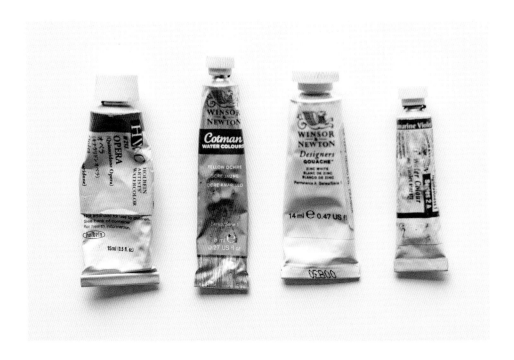

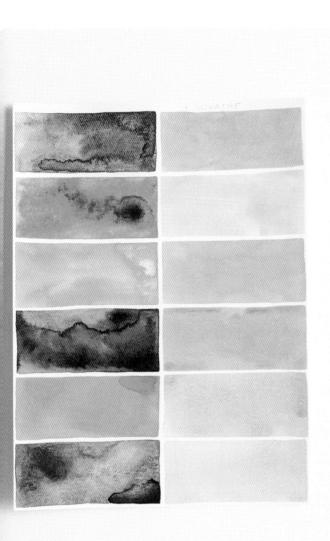

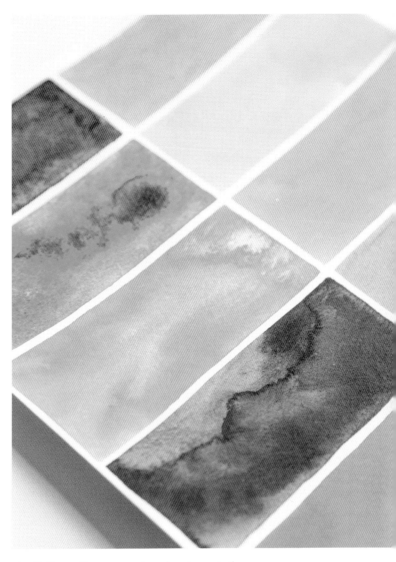

Examples of how mixing white gouache with watercolors works. Both use the same watercolor pigment; the one on the left is made with plain water and the one on the right has a bit of white gouache mixed in. You can also notice there's quite a change in texture when adding gouache. In the close-up image, you can appreciate watercolor's interesting textures, while the swatches that integrate gouache are flat. Depending on the style you're aiming for, it can be an interesting way to work.

ALL THAT SHIMMERS

Metallic, Pearlescent & Iridescent Watercolors

I've always been drawn to embellishing my artwork with sparkling textures. Shiny details make me feel as though I am adding a mysterious, majestic aspect to my work—that final touch of magic and elegance.

The first time I can remember admiring the use of gold leaf in classic art was seeing the brilliant work of Gustav Klimt. Using gold leaf, copper leaf, or silver leaf is the traditional way of adding vibrant metallic reflections to your work. Although I thoroughly enjoy the use of traditional gold leaf, it can be tricky and meticulous. Recently, I have been on the hunt for metallic paint that's easier to use than the historically traditional ways of applying gold leaf, which require a special adhesive and lots of precision and patience.

Metallic Inks

The first type of paint I found to be effective was Winsor & Newton gold ink, which is also available in silver. This is a water-resistant ink that dries rather quickly on paper. You can use it with a paint brush, dip pen, or airbrush. This type of paint is considered a drawing ink, which makes it good for fine detail.

Metallic Acrylic Paints

I later discovered a variety of acrylic paints that are thick and opaque. These are also fun to use but they don't have the "flowy" characteristic that watercolor or ink does. I have not dived deep into metallic acrylics, but some common brands are DecoArt, Golden, and Pebeo.

When I talk about brands, keep in mind that these are suggestions. Availability may differ depending on geographical location and budget. Don't limit your creative practice if you can't find a specific brand I suggest. In reality, the best way to discover supplies is to visit your local art supply store and ask around, then experiment at home. There are so many types of paints out there—many I am not even aware of yet that might be available in your hometown or found during your travels. In fact, some of the best paints I have are actually handmade, or even obscure.

Pearlescent, Iridescent & Metallic Watercolors: Handmade & Commercial

Which leads me to my discovery of handmade pearlescent, iridescent, and metallic watercolors—my favorite shiny medium so far. Around 2015 I found myself interested in learning how to make my own watercolors. I had taken a class in college but felt it was time to refresh my knowledge and explore using high-quality pigments.

I found a tiny shop in New York that hosts "make your own watercolor pan set" classes, so I signed up for a class using rare earths and minerals as pigments and flew to New York. The class included a bonus paint using synthetic gold, just because it looked so visually appealing next to the earthy paints we created during class. This paint glimmered like no other!

After completing the class and making my own paints, I was so taken with this gold I decided to purchase a complete handmade pearlescent set they had in the shop, which included a variety of gold tones, copper, and shimmery pearlescent paints with opal-like undertones.

The texture is smooth and easy to work with and the coverage is great. The best part about these watercolors is they blend perfectly with any other type of watercolor, so you can mix your own one-of-a-kind colors using these paints as a base.

A few years later I was teaching a workshop (coincidentally in New York again) and a lovely student brought gifts to share. The thoughtful gift included a couple of HydraColour watercolors for me to try. This brand of paint is handmade by an Etsy seller and her pigments are amazing. She goes beyond classic golds and pearlescents to create amazing holographic effects, with pigment mixes that look like liquid galaxies and all kinds of shimmery magic. I fell in love with her paints and I place an order every time I host one of my retreats so students can try them as well. I want everyone to try these!

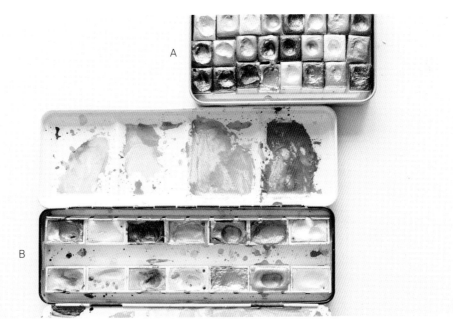

Handmade pearlescent watercolor paints by HydraColour (A) and Kremer Pigments (B).

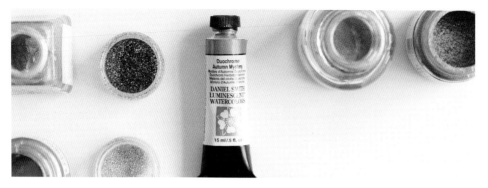

A tube of Daniel Smith Watercolor shown with metallic pigments and gold dust.

Metallic Pigments & Gold Dust

I've also found using pure metallic pigment or gold dust is a great way to integrate these textures into your work. You must use gold leaf adhesive as a base, then sprinkle a bit of gold leaf on top of the adhesive—the same way you would when using glitter. In fact, you can also use fine glitter to add detail to your work. Glitter is messier than paint but can come in handy depending on the effect you want.

I recommend subtlety when adding sparkle and shine to your artwork. A little goes a long way and being mindful of these special effects will keep your artwork looking sophisticated, not overworked or juvenile.

MORE METALLIC WATERCOLORS TO EXPLORE

- - -

In this book I demonstrate supplies I like, but that doesn't mean there aren't additional options available. There are many brands and interesting shimmery mediums out there for you to try! Here are a few that aren't pictured in this book:

- Daler-Rowney FW Pearlescent Liquid Acrylic Artists' Inks
- Finetec Pearlcolors
- Kuretake Gansai Tambi Pearl Colors and Starry Colors
- Sakura Koi
- Sargent Watercolor Liquid Metal Pans
- Schmincke Aqua Bronze

There are many more brands and types of watercolor metallic paints, including watercolor tubes, like the Daniel Smith tube shown above.

Swatching Shimmery Paints

In general, paint looks quite different once it's dried on paper, so swatching is always a great idea—even with your regular watercolors.

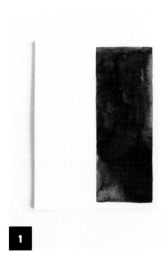

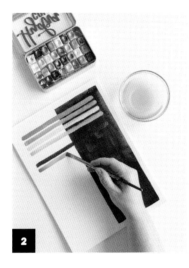

1 On one half of your paper, paint a large black rectangle using black India ink or watercolor. Leave the other half of your paper blank. Let dry.

2 Starting in the white section and continuing over to the black side of the paper, paint a narrow band of each of your paints. This is a great way to observe contrast.

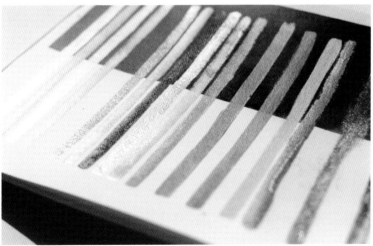

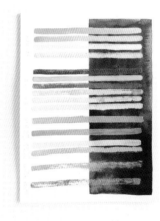

3 Wait for your paints to dry to discover their true effects. You'll also see that shimmery paints are especially noticeable when they're applied over a dark background.

4 Test swatches of a few of the paints described on pages 15 and 20. I recommend that you also add the color and brand names so you can easily identify them when you refer to your chart later.

SPECIALTY WATERCOLORS

Neon, Multipigmented & Rare Pigments

I started collecting rare watercolors after I took the rare earths and minerals workshop I mentioned. It was eye-opening to discover where pigments come from and to observe different types of granulation once applied to paper. Before this I had used more classical and smooth types of watercolors, but after making my own set using rustic pigments, I began to really appreciate the natural earth textures.

My collection of paints continued to grow when a student at a watercolor retreat I was teaching in Sicily gave me a full dot card with samples of Daniel Smith watercolors. I became fascinated with their multipigmented watercolors, such as Moonglow and Cascade Green. When these paints dry, a special mix of organic and inorganic pigments in the formula creates tension and actually separates on the paper. This creates beautiful edge effects and granulation in certain areas.

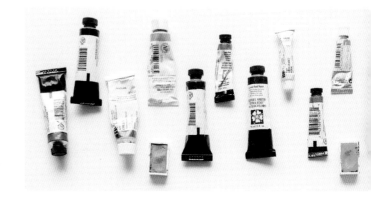

A similar effect occurs with colors like Lunar Blue, Lunar Black, or Lunar Red Rock, also by Daniel Smith. All these colors feel mysterious and moody because of the extreme granulation. Lunar Black actually contains pigment particles that react magnetically! These minuscule shavings react to each other the way a magnet would, repelling and attracting each other. This line is fantastic for creating outer-space landscapes.

Another fascinating line from Daniel Smith is the Genuine series. These paints also have really interesting granulation effects. My favorite is Amethyst Genuine because it contains crushed particles of the gemstone, which give off a subtle sparkle. It's stunning!

I also enjoy collecting tubes of colors not usually found in basic pan set collections, like Cobalt Turquoise by Schmincke or various Holbein tubes, which come in a variety of creamy colors, such as Lavender or Brilliant Pink. Holbein also has the best Opera Pink I've ever tried (*and I've tried a few!*). Holbein's pink is so bright it's almost fluorescent. Integrating this paint into the mix will give vibrance to your warm tones and is interesting to use instead of red if you're looking for a bright color palette.

There's a whole world of specialty watercolors out there, each one special in its own way. I've swatched some of my favorites here. If any of these catch your eye, it's worth it to invest in a couple to try.

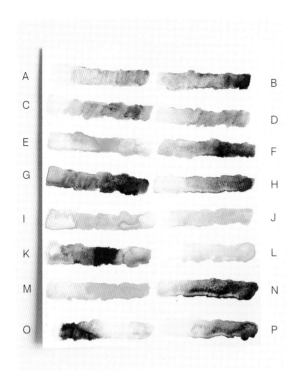

A. Hematite Violet / Daniel Smith
B. Lunar Black / Daniel Smith
C. Cascade Green / Daniel Smith
D. Shadow Violet / Daniel Smith
E. Cobalt Turquoise / Schmincke
F. Moonglow / Daniel Smith
G. Piemontite Genuine / Daniel Smith
H. Opera / Holbein
I. Brilliant Pink / Holbein
J. Lavender / Holbein
K. Lunar Red Rock / Daniel Smith
L. Fluorescent Pigment Green / Kremer
M. Fluorescent Pigment Flame Red / Kremer
N. Lunar Violet / Daniel Smith
O. Lunar Blue / Daniel Smith
P. Amethyst Genuine / Daniel Smith

A NOTE ON NEONS

– – –

Neon or fluorescent watercolors, such as Fluorescent Pigment Green and Fluorescent Pigment Flame Red (L and M above), are extremely difficult to photograph and don't scan well either. These types of pigments are truly meant to be admired in person. For reference, here's an example of what Fluorescent Pigment Flame Red looks like from a different angle and under different lighting.

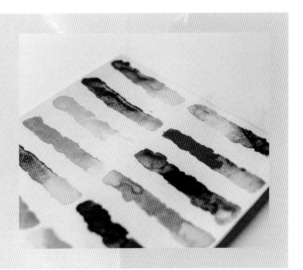

INKS

There are two basic inks I always have on hand to complement my watercolor paintings: black India ink and opaque white ink. These two basics are much more opaque than watercolors and also provide distinct qualities in both texture and detail.

I always go back to Dr. Ph. Martin's Bombay Black India ink. This ink is waterproof and flows smoothly. As for white ink, of all the brands I've tried, my absolute favorite is Copic Opaque White.

There are different types of whites you can use over watercolors, including acrylic ink, drawing ink, gouache, acrylic, white pens, and oil-based markers.

Once again, please don't feel as though you have to use the brands I suggest. There's a virtual sea of magnificent supplies out there—work with what you've got.

Black ink (left) and white ink (right).

BRUSHES

Watercolor bushes come in a variety of sizes, shapes, and bristles. Traditionally, water-colorists have used natural brushes made of sable or other animal hair. However, these types of brushes are too soft for the illustrative style of watercolor I'm sharing in this book. I find synthetic bristle brushes better suited for this type of art.

I usually work with a variety of round brushes, ranging from size 000 to size 10. You can work well if you have at least three round brushes: a large brush, like a size 8; a medium or small brush, like a size 2; and a liner brush, or size 0, for small details.

The projects in this book also require a flat round brush, a flat brush, and a few brushes you aren't too attached to. Some mediums used in this book will be harsh on your brushes, and you don't want to ruin your favorite brush!

The brands I've been enjoying are Winsor & Newton and Princeton.

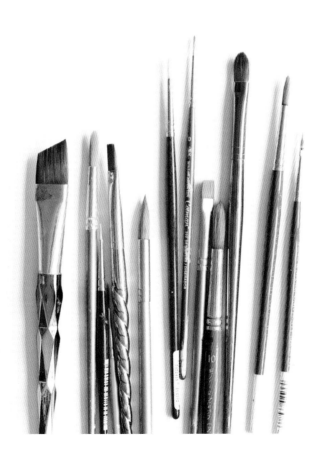

PAPER

For the activities in this book, I mostly use Canson XL watercolor paper. This paper is cold-press textured and natural white; it also has a nice thickness. I recommend a paper like this because we do a lot of experiments, so you don't need to use expensive high-end paper for those activities. Canson XL is modestly priced, which allows you the freedom to test, experiment, and play without feeling as though you're wasting expensive paper that should be reserved for a work of art. Optional papers are black watercolor paper and blank watercolor greeting cards. Of course, you may use any type of watercolor paper you have.

Watercolor paper comes in a variety of sizes, textures, and weights—all a matter of preference. Textures go from rough, cold press (less texture but still textured), and hot press (smooth).

OTHER TOOLS & SUPPLIES

Basic Supplies

A few basic supplies to have on hand include a compass, eraser, pencil, pencil sharpener, ruler, scissors, and washi tape.

Tools for Manipulating Paints and Inks

As we will use some mediums that will be tough on your brushes, you can use cotton swabs for certain activities. You might want some tweezers on hand for small decorative elements and a toothbrush can work for spatter. Having a few small dishes to isolate certain mediums will also come in handy.

Additional supplies you can play with in this book include:

- Clear wax crayon
- Household supplies such as acetone, bleach, instant coffee, plastic wrap, rubbing alcohol, salt, and tissue paper
- Masking fluid
- Watercolor pencils

Embellishments

Don't hold back when adding various craft supplies to your watercolor paintings. If done correctly, incorporating embellishments can look stylish. In this book I demonstrate star confetti, stickers, glitter, glitter glue, and gold leaf flakes. Feel free to use what you have on hand. The experiments (see page 34) offer a great chance to use any fun craft supply you've been collecting! Get creative and mix it up.

2

BASIC TECHNIQUES & BEYOND

- - - - - -

In this chapter I review the basics of watercolors and why watercolors are the preferred medium of so many artists. We will also have fun experimenting and documenting the many ways watercolors react with all kinds of household supplies. Be prepared to be amazed!

WATERCOLOR PROPERTIES

Watercolor has many special qualities that are unique to this medium. Paint is commonly translucent and activates with water on the palette. This brings up a few important characteristics. To use watercolor, it's important to get the amount of water right. I usually find that students use *too little* instead of *too much* water. It's important to get a nice flow going, depending on the level of opacity you want. Another important topic when working with watercolors is layering. Because this medium is translucent, you begin painting with light layers and work up to darker layers. It's important to reserve your white and light values for layering; the white of the paper serves as light value and the amount of pigment you add to a color will determine its saturation.

Watercolors work best on heavy-weight watercolor paper, which is high in absorbency. Working on an unfit surface, one that can't handle the amount of water used for this medium, can end up being a disaster!

Something else to keep in mind when working with watercolor is finding a balance between planning and spontaneity. Although it's important to plan your layers because correction is tricky—there really is no "painting over" an area to fix mistakes as there is when painting with acrylics—it's also important to be vigilant of the drying game. Waiting for areas to dry before painting next to them is the only way to prevent sections from bleeding into each other. On the other hand, the more you paint, the more you trust watercolor to do its thing. Interesting textures and effects will wondrously appear.

It's no mystery why watercolor is one of the most beloved mediums for artists and enthusiasts alike. The medium is quite sensual, trapping you for hours. It is also extremely practical, offering enjoyment by creatives at any level.

Yet more reasons to love watercolors include:

• Easy clean up; not too messy
• Easy on your brushes
• Less waste—watercolors can be reactivated infinitely,
 even when completely dry on the palette
• Lots of happy accidents
• Lower toxicity in comparison to other mediums
• No complicated mixing agents—just water
• No odors
• Portable; great for travel
• Pure way to work with pigments
• Relatively inexpensive because of its long-lasting nature

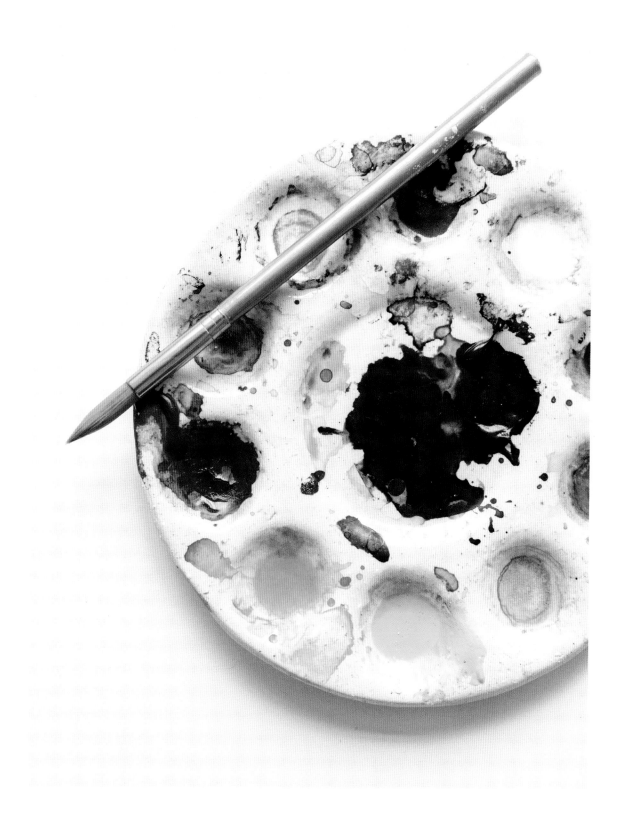

Handling Your Paints

To use a watercolor pan set, pick up some water with your brush and lather one of the paint cakes. I like to moisten my paint a bit before using it. Once you have a nice lather going, take the paint from your pan and add it to your palette. Don't skip this step. If you use paint directly from the pan, you will not be able to control the value of the color. Once you have some paint on your palette you can either add more water or mix in a different color to create a new shade **(A)**.

This same principle applies to tubes or liquids **(B) (C)**. Squeeze a bit of paint from a tube or add a drop of liquid watercolor to your palette. This will give you control of how much paint you use. Some artists like to personalize a palette by squeezing different tubes onto a fresh palette and letting the paint dry on the palette. The paints will continue to react to water forever!

You can work with any of these formulations of watercolor. I use all three and mix them to create unique colors and effects. Experiment and discover what works best for you.

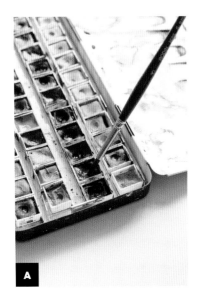

Wet on Wet & Wet on Dry

The two main methods we use in this book are **wet on dry** and **wet on wet**.

Wet on dry. Use wet paint over a dry surface. This method is great for an illustrative style.

Wet on wet. Use wet paint over a wet surface. Add clean water to a specific area and gently add wet paint to the wet area. This is great for flow effects—your paint will expand and the effects will vary depending on the amount of water and the concentration of paint you use.

In **(D)**, the swatches on the left are wet on wet; on the right, wet on dry. These two methods can also be used to blend different colors.

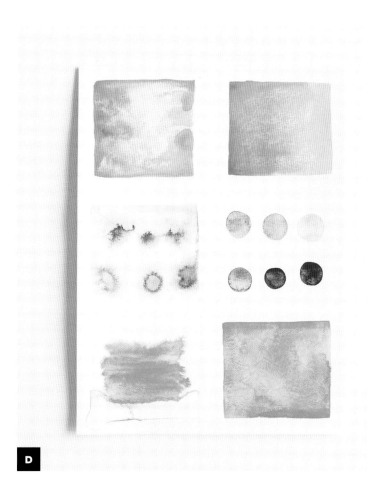

D

EXPERIMENTING WITH MIXED MEDIA

There's one word I consistently repeat to students: experiment!

Yes, art techniques can be taught and, of course, there are certain aspects to each medium that will help you with your artistic learnings, but the number one thing I encourage is play. So much can be discovered when you're not taking artmaking *too* seriously. Don't be afraid to "waste paint," because art is a practice, not a result. Besides, as you'll discover, there are cool ways to upcycle your experiments.

It's time to get out any and all supplies you have at home or in your studio. Maybe you purchased a fun metallic paint years ago but haven't found a way to integrate it into your artwork. How about those liquid watercolors you'd like to try? Or mixing paints with easy-to-find household supplies you probably have handy? Let's paint!

All of the following experiments are designed to encourage you to test and observe. There are no rules when creating art. Of course, there will be times when the desired effect may not turn out exactly the way you hoped, but that's okay—there is no right or wrong, it's all part of the creative process. Try any or all watercolor and mixed-media experiments; use what you have! If you're missing a supply, don't let that stop you, and if you're curious to try something else, do it. Experiment!

Prepare Your Paper

1 Start by dividing your paper into sections. Here, I'm using a 9" × 12" (23 × 30 cm) cold-press water-color paper by Canson and I have divided my paper into four sections. You can create as many sections as you like; it's totally up to you and the size of your paper.

2 Using a pencil and ruler, firmly place washi tape over each of your lines and the edges of your paper. This will secure perfect frames without having to worry about the edges of each swatch experiment.

Salt Over Watercolor

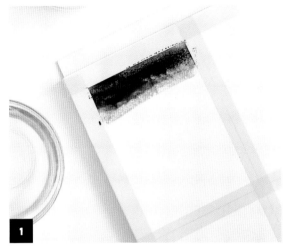

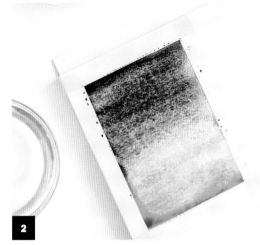

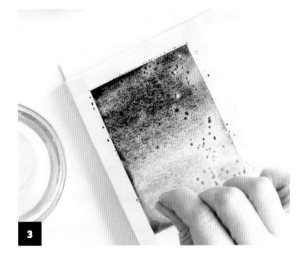

1 Begin by choosing a couple of colors. While the paint is still wet, add the second color right next to the first color to create a natural watercolor blend.

2 Here I've used a mix of violet from my Sennelier pan set at the top, and some Dr. Ph. Martin's Hydrus Fine Art Watercolor in turquoise blue below it. I like to try out different types of watercolor in these experiments because every factor influences the results.

3 Carefully sprinkle salt on the wet paint. Any type of salt will work—experiment! Let dry and see magic happen before your eyes. Remove the salt once the area has dried completely.

Bleach Over Watercolor

This effect is so much fun—it reminds me of tie-dye!

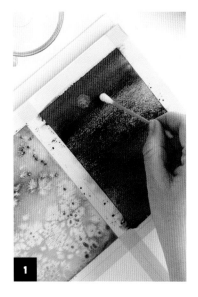

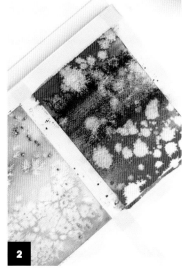

1 Paint an area with watercolor paint and let it dry a bit. While the paint is still humid, grab a cotton swab and dab bleach onto your wet paint.

2 As the area dries, white bursts will magically appear! The effect is influenced by the brand and type of paint as well as its pigment and degree of saturation. At the top I used pan watercolors; the hot pink paint below it is Dr. Ph. Martin's Synchromatic Transparent Water Color, which is dye-based rather than pigment-based.

Ink Over Water

This next swatch isn't technically watercolor based, but it's important to observe the ink-and-water interaction.

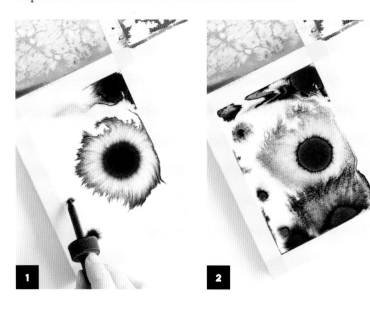

1 Begin by adding a layer of clean water as your base. Carefully add small drops of black India ink to your wet paper. This will most definitely cause a "wow" reaction! The way the ink flows onto the paper is endless entertainment.

2 The ink blotches will continue to transform as the paint dries. These make me think of some sort of black hole in outer space, or even a portal to another dimension. Let your imagination guide you; sometimes experiments like this are great ways for coming up with new painting ideas.

Watercolor Mixed with Gouache

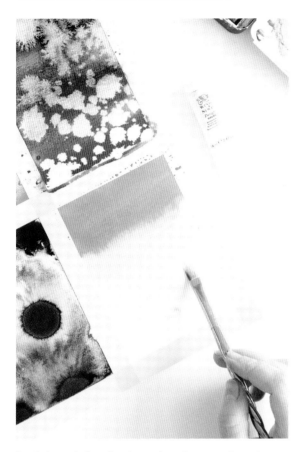

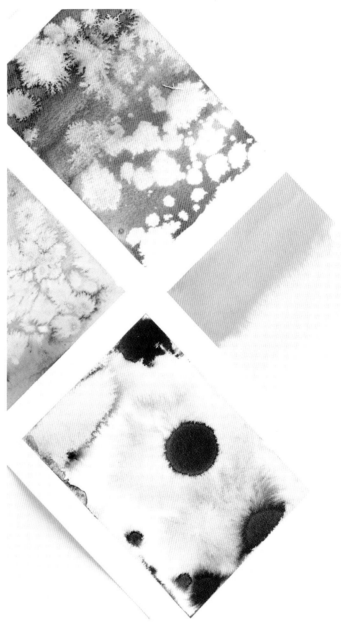

Begin by painting simple strokes of watercolor paint and blend in white gouache carefully. Notice how the opaque nature of gouache immediately stops the blending process and switches to a chalky texture, as opposed to watercolor's translucent nature. Gouache is sometimes referred to as opaque watercolor. The gouache and watercolor blend so well together but the pigment in gouache is much more opaque. Adding a touch of any watercolor color to white gouache is a fun way to create pastel colors.

Spattering Watercolor on a Wet Surface

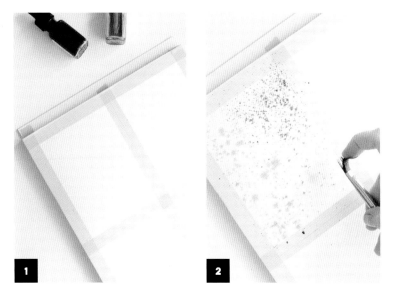

1 Begin by adding clean water to one of your swatch areas. The surface should be just moist, not a wet puddle.

2 Prepare some watered-down watercolor paint so it's easy to pick up with your brush. Here I'm using Dr. Ph. Martin liquid watercolors because the colors are fun, but you can use any type of water-color paint, or even ink. Using a flat brush, pick up enough paint to spatter, and spatter it around your wet surface. The paint will softly dissolve into the background. You can also use a toothbrush or fan brush to create spatter.

Creating Cloud Textures

This technique is also a good way to lift off paint if you made a mistake or spilled some paint.

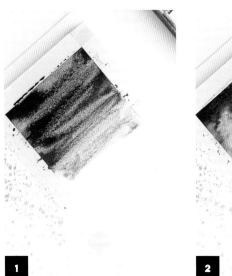 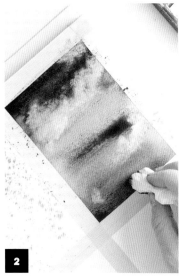

1 Begin this experiment by painting the area with watercolors as a base. I'm using different gradients of blue here.

2 While the paint is still wet, grab some tissue paper and wrinkle it up with your hand. Dab your wet paint with an edge of the tissue paper to lift off the paint. This creates a fun, simple cloud texture.

Testing Metallics

If you have metallic watercolors, an interesting way to test them is simply to blend the metallics with regular watercolor paints while both are still wet.

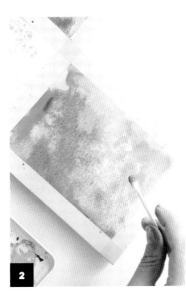

1 Begin by adding a bit of regular watercolor paint to your paper, then add whichever metallic paint you want to try and observe how they blend together. You might even achieve a fun marbled effect by letting the paint do its thing!

2 Feel free to sprinkle a bit of gold dust or glitter into your color glaze and see what happens. This effect is hard to photograph and looks much more impressive in person.

Ink Over Watercolor

Watercolor and ink interact beautifully together.

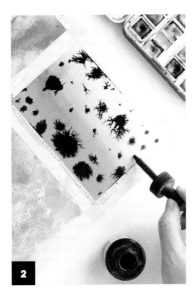

1 Paint an area of plain watercolor.

2 While the paint is still wet, carefully place small drops of black India ink onto the paint. The ink will spread, creating amazing spiderlike textures! This effect makes me think of lightning, or roots from a large tree. The way ink reacts to a layer of watercolor versus pure water (see page 36) is quite different.

Mixing Watercolor & Rubbing Alcohol

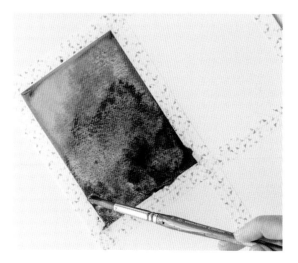

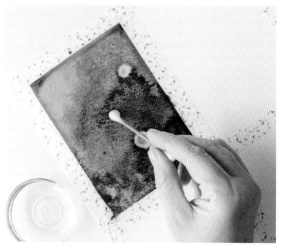

1 Begin by painting the area with any type of watercolor. I'm using a mix of colors I had on my palette, including my pan set violet and some magenta liquid watercolor.

2 While the paint is still wet, use a cotton swab to dab drops of rubbing alcohol onto the watercolor wash.

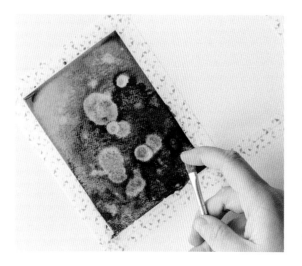

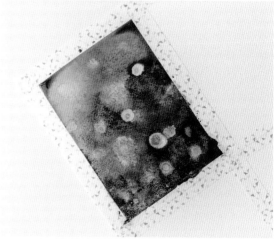

3 For smaller scattered effects, play around with spattering rubbing alcohol, using an old flat brush or toothbrush.

4 While doing these experiments, keep notes on how these materials react to different types of watercolor and even different pigments.

Another Wet-on-Wet Technique

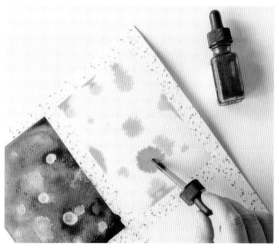

1 Wet the area of your paper with clean water and have a few liquid watercolors handy.

2 Using a dropper, place drops of liquid watercolor around the wet paper. Let it flow in any direction.

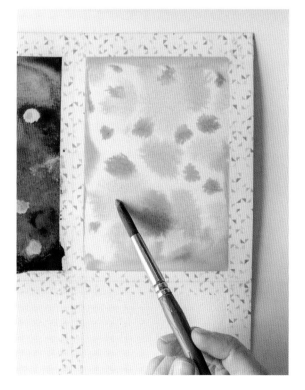

3 Add some of your pan or tube watercolors between the liquid watercolor drops and observe how everything blends on its own.

Watercolor Pencil Shavings

This experiment is a fun way to use watercolor pencils.

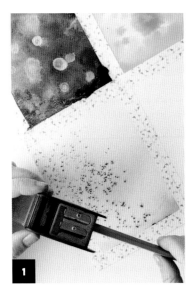

1 Begin by adding a layer of clean water to your area. Using a pencil sharpener, carefully turn the edge of a watercolor pencil over the wet area. The goal here is to get only sprinkles of the color and not actually sharpen the pencil. You could also use an X-Acto knife for this step.

2 The colors will dissolve around the edges but will leave the crisp texture of the watercolor pencil specks. It almost looks like confetti. The wetter your paper is, the more the particles will dissolve.

Magnetic and Metallic Watercolors

Here I play with a specialty watercolor called Lunar Black by Daniel Smith. This type of paint has tiny magnetic particles that repel and attract each other. This is why we can observe that interesting granulation effect.

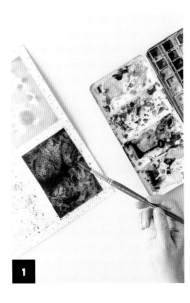 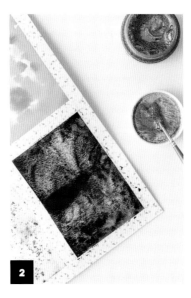

1 I mix a bit of regular indigo paint with the Lunar Black because it reminds me of the night sky.

2 While the paint is still wet, try adding dots of metallic paint to see what happens.

Creating Texture with Plastic Wrap

For this next effect to work, the paint must dry completely before we can lift off the plastic wrap.

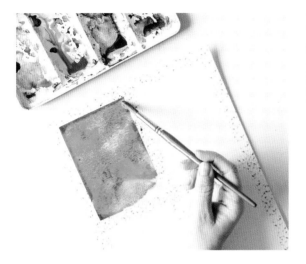

1 Paint an area with a mix of any type of watercolor. Make sure to use enough water.

2 Place a piece of plastic wrap over your wet watercolor area.

3 Using your fingers, gently manipulate the plastic wrap to create an interesting texture. Let dry completely while you do other experiments before removing the plastic wrap. (See page 45 for the final effect.)

Coffee as Watercolor

Painting with coffee is a romantic art technique similar to watercolor because the tint of the coffee acts like a pigment. It has a vintage look similar to sepia photography.

1 Instant coffee dissolved in hot water works best for this technique. Let cool before using.

2 Just as with watercolor, the amount of water used will influence the desired transparency or opacity of the color. Feel free to experiment with wet on wet, wet on dry, or even adding sprinkles of coffee to clean water.

Mixing Watercolor & Acetone

You'll need acetone, or nail polish remover, for this effect.

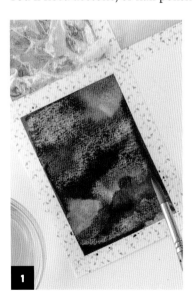 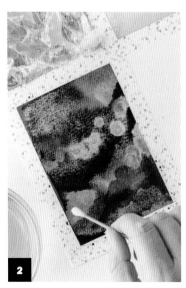

1 Add a layer of watercolor paint. Mix in different types of paints or paint colors.

2 While the paint is still wet, use a cotton swab to drop acetone or nail polish remover in different areas. I really like this effect. If you place the acetone drops right, you can imagine them as part of a cloud or nebulae landscape!

Wax Crayon Resist

For this last experiment, you'll need a clear wax crayon or white crayon. You could also use any colored crayon for a different effect!

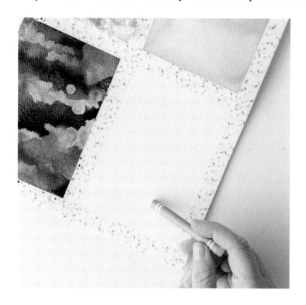

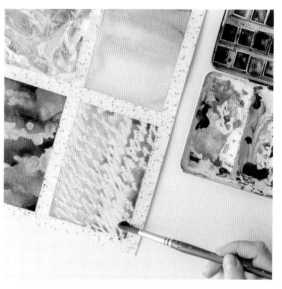

1 On dry paper, scribble any drawing of texture with the crayon.

2 Paint over the drawing with watercolors to reveal the texture. The wax from the crayon resists water, revealing white paper underneath.

PLASTIC WRAP REVEAL

- - -

Now that we've finished all the experiments and our plastic wrap experiment has had sufficient time to dry, we're ready to reveal this interesting texture.

Carefully remove the plastic wrap. Imagine this texture, with the blue colors, as an ocean landscape. This is why I love swatching these experiments—new ideas and inspiration can emerge from just playing and observing.

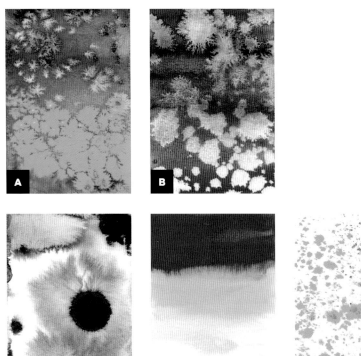

A. Salt Over Watercolor (page 35)

B. Bleach Over Watercolor (page 36)

C. Ink Over Water (page 36)

D. Watercolor Mixed with Gouache (page 37)

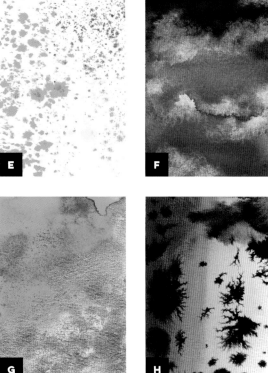

E. Spattering Watercolor on a Wet Surface (page 38)

F. Creating Cloud Textures (page 38)

G. Testing Metallics (page 39)

H. Ink Over Watercolor (page 39)

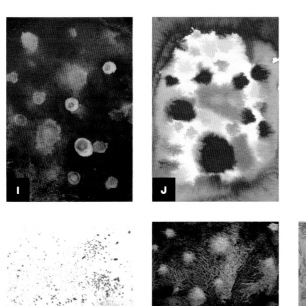

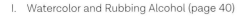

I. Watercolor and Rubbing Alcohol (page 40)

J. Another Wet-on-Wet Technique (page 41)

K. Watercolor Pencil Shavings (page 42)

L. Magnetic and Metallic Watercolors (page 42)

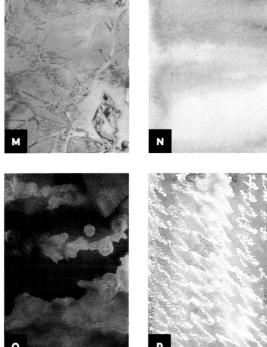

M. Creating Texture with Plastic Wrap (page 43)

N. Coffee as Watercolor (page 44)

O. Mixing Watercolor and Acetone (page 44)

P. Wax Crayon Resist (page 45)

3

HORIZONS

- - - - - -

I've always been inspired to paint the sky. Daytime sky, starry nights, storms, and tranquil sunsets always feel calming and refreshing to paint. There's something so loose and vast about the sky—watercolor is the perfect medium to use because of its unpredictable, loose nature. With some help from mixed media, you'll be able to create simple and delightful horizons.

PREPARING YOUR SURFACE
FOR PAINTING SKIES

For the series of skies in this chapter, I demonstrate techniques within large circles, protecting the outer edges with masking fluid. Painting mixed-media textures is the perfect opportunity to use this complementary watercolor medium.

For more tips on using masking fluid, see page 105.

1 To prepare your sky canvas, use a compass to trace large circles on watercolor paper.

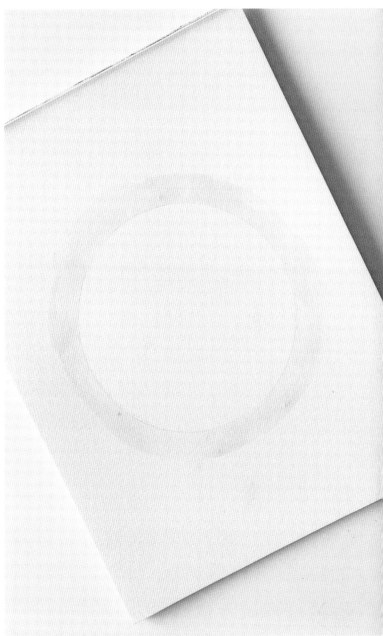

2 With a large flat brush, paint a thick border of masking fluid around the outer edge of each circle, making the border at least 1" (2.5 cm) wide.

3 Wait for the masking fluid to dry completely before you paint inside the circle.

OPEN SKIES

This simple technique creates beautiful and serene landscape backgrounds. This is one of those days where the sky is so blue and the clouds look soft and light. This technique is inspired by the watercolor experiment on page 38.

Once your masking fluid border (see page 105) is completely dry, you're ready to begin painting.

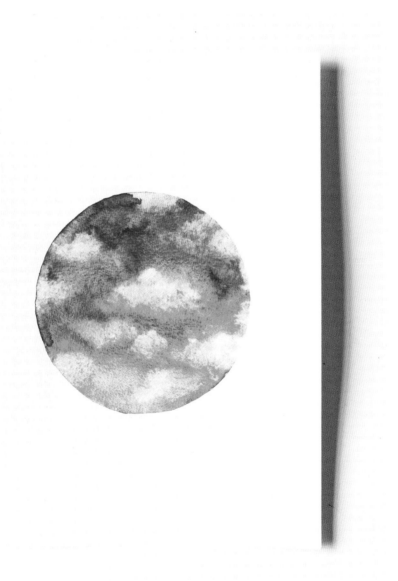

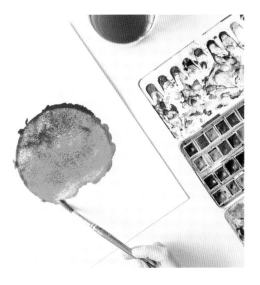

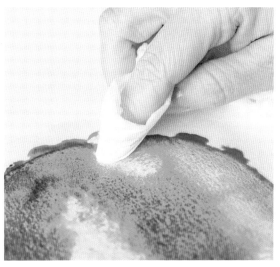

1 Start by mixing some watercolor paint with two different shades of blue. You're going to create an effortless gradient within the circle. Begin with just one tone and, while the paint is still wet, finish the rest of the circle with the other tone.

2 Be quick! Now we're going to lift up some of the paint. Your watercolor area must still be wet for this to work. Grab a tissue and use it to gently dab the wet paint in specific areas to reveal soft clouds.

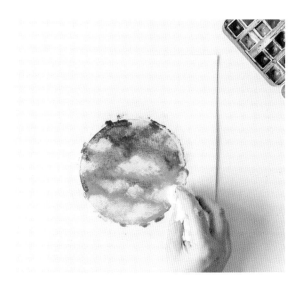

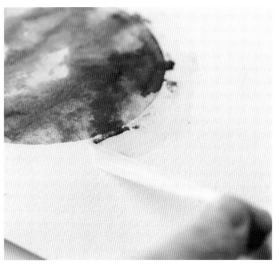

3 You can repeat the process in certain areas to expose more white from the paper, which will give the clouds more puffiness and volume. The more pressure you apply to the paper, the more color you'll lift and the more you'll expose the white from your paper.

4 Let the paint dry, then carefully lift up the masking fluid to reveal crisp, clean edges around your circle.

BILLOWING CLOUDS

This style of puffy clouds is great for fantasy artwork and works well with a variety of color schemes. You could also use a warmer color palette of oranges, yellows, reds, and warm violets for a dramatic sunset effect.

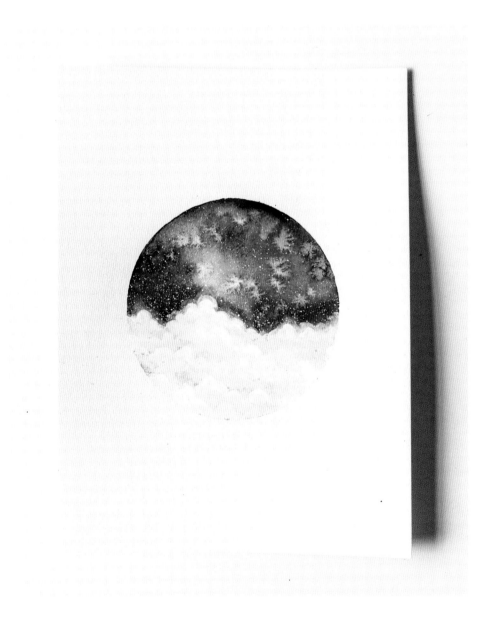

1 Draw simple puffy clouds. They will almost appear cartoonlike at this point. Don't worry—they'll look more realistic as we add layers of paint.

2 Fill in the clouds using bright watercolors. The color will look very saturated at this point but that will change when we add white ink. Let each section dry before you paint the one next to it to avoid bleeding. Continue to paint, section by section, letting the neighboring areas dry.

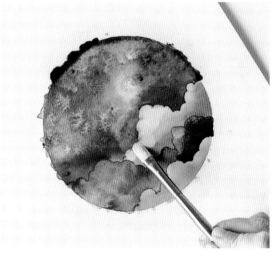

3 Paint the sky portion of the composition—I'm using blue and sprinkling on a tiny bit of salt for a bursting texture. This specific style is meant to be in the fantasy realm. Let all areas dry.

4 Using a flat round brush similar in size to the round parts of your puffy clouds, tap in some diluted white ink.

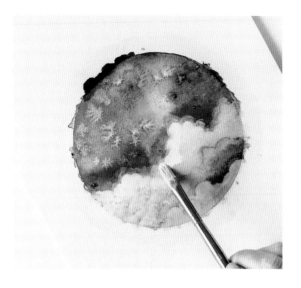

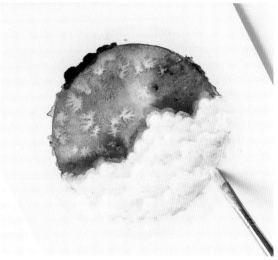

5 This is the first layer of white paint and it will be a bit translucent, but the puffy texture will start to appear.

6 When the first layer of white paint is dry, go in with a bit more white ink. This time make it more concentrated and be more mindful of where you add the paint. This step gives the clouds more dimension.

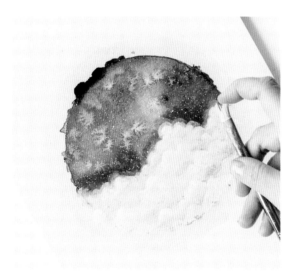

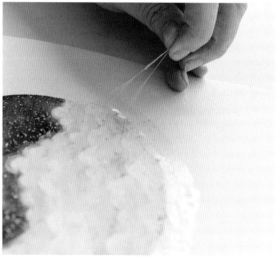

7 For a misty touch, finish the painting by adding a bit of white spatter where the clouds meet the sky.

8 Let the paint dry, then carefully lift up the masking fluid to reveal crisp, clean edges around your circle.

OCEAN SUNRISE

Where I grew up in the Caribbean, we would get the most beautiful sunrises with colors that looked like cotton candy and pastel pinks. The morning calmness with the powerful sun coming up illuminates the entire sky for a few sacred moments. The effect in this activity is inspired by the calmness and stillness the medium creates naturally due to its creamy texture.

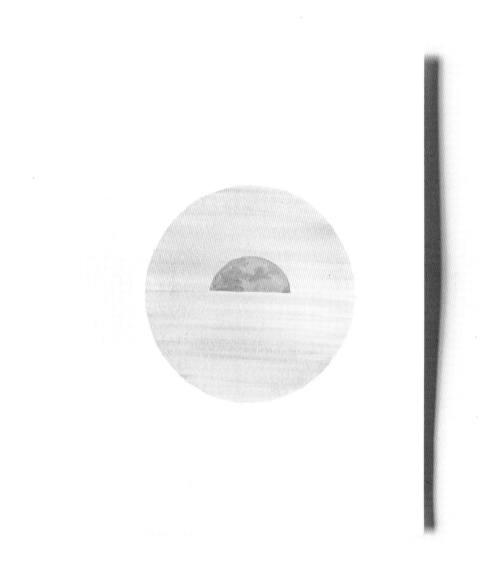

1 Trace a straight line through the center of your circle. This will be your horizon line, where the sea meets the sky.

2 Using a compass or any tool to trace a circle, draw a half circle around the center point of your drawing.

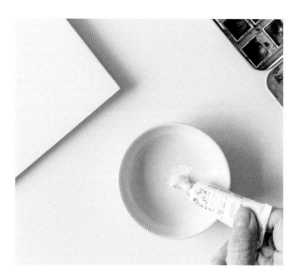

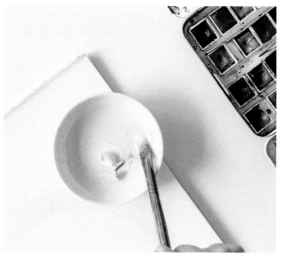

3 For this technique, use white gouache mixed into watercolors. Because gouache is also known as opaque watercolor, the effect we're after here is a chalky texture added to your watercolor paints, which are usually translucent. In this case we're aiming for a creamy pastel-like look, so mixing a bit of white gouache into our watercolor paints is the perfect medium.

4 Pick up a bit of watercolor paint and add that into your white gouache dish. Don't mix it in completely, just make sure your paint brush picks up a bit of both paints. I recommend having a few isolated small palettes to keep your inks and gouache separate from the general space where you mix your watercolor paints.

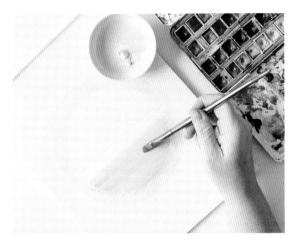

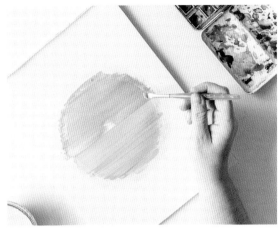

5 Using a flat brush, glide your brush from side to side, making sure not to blend the colors too much. You want a bit of contrast to achieve that horizontal ocean effect. Having a masking fluid border to protect your edges is extremely useful here; you are free to glide your brush from side to side without thinking about the edge of the canvas.

6 Using the same method described in step 5, pick up warmer colors for the sky and place them on the bowl where you're mixing your gouache. I'm using a bit of orange and yellow, and touches of blue from the paint we used for the ocean. Because we're mixing in white gouache, the colors that were once vibrant and bright will become soft and opaque. For example, a bright orange will now have more of a peach tone. These are great colors for a soft sunrise.

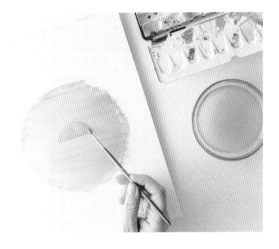

7 You can go a bit over the area where your sun will be, it's okay. Metallic paint will cover that up. You could also mask the sun area, if you feel it's necessary.

8 Once your ocean and sky areas have dried completely, go in with some pearlescent watercolor paint to fill in the half circle representing the sun. I'm using a lovely soft copper tone from my Kremer Pigmente set.

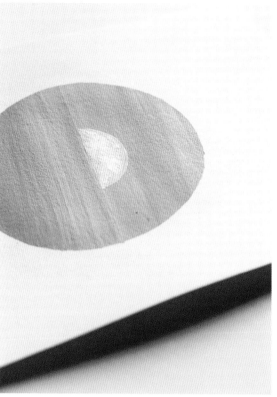

9 Lift up the masking fluid to reveal . . .

10 . . . a beautiful, crisp sunrise landscape.

LIGHTNING STORM

Painting lightning storms is surprisingly simple and creates a dramatic effect for dark skies. This method could also be used to paint any night sky—swap the lightning bolts for small dots to represent stars.

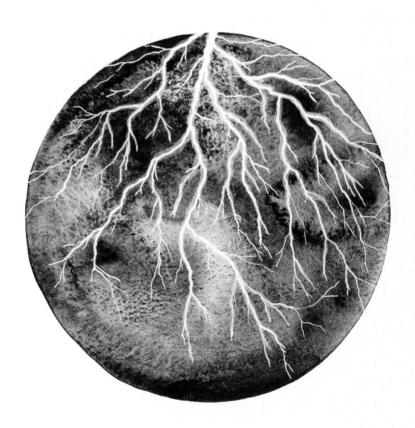

1 Trace a circle. Masking fluid is not necessary for this activity because we are not creating a complicated texture that needs protected edges. Instead, we are creating a wet watercolor wash with different colors within the circle. I'm using some interesting pigments here to achieve a granulated texture. In my palette I have some liquid watercolor violet by Dr. Ph. Martin, regular indigo from my pan set, and Lunar Black by Daniel Smith—this pigment gives the wash that exciting granulation effect. The pigment particles react like magnets, repelling against each other. Pure alchemy! Paint your circle.

2 Let the circle of paint dry completely. Once dried, using a clean dish, add a bit of white ink. I like the brand Copic. This can also work with opaque white gouache. Water down your white ink to create these initial squiggly lines, which are a bit thicker because they represent the glowing area that surrounds your actual lightning bolts. It helps to look at photos of lightning to define the shapes.

3 Once your watered-down lines dry, paint the lightning shapes. Use a thicker mix of paint and a liner brush. You want to achieve opaque, thin lines for this final step. Proceed to paint over the glowing area with thin and tiny zigzag lines.

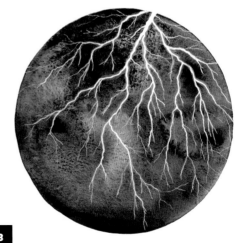

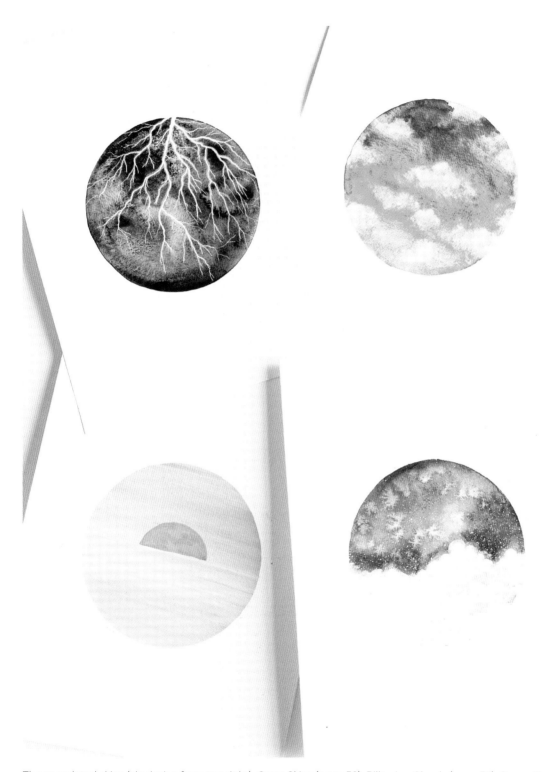

The completed skies (clockwise from top right): Open Skies (page 52), Billowing Clouds (page 54), Ocean Sunrise (page 57), and Lightning Storm (page 61).

MESSAGE HIDDEN IN THE CLOUDS

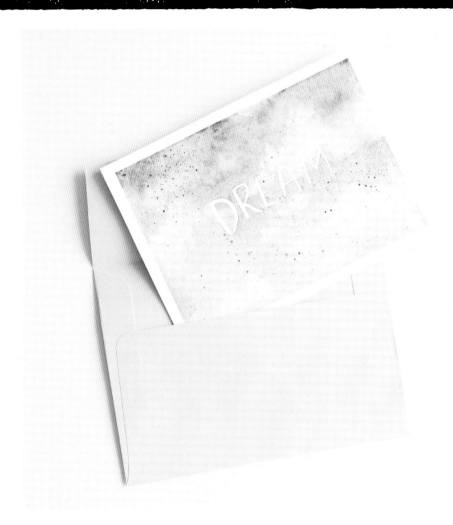

This project is a really fun way to share a special message. The reason it's so opportune to use masking fluid for lettering here is because you're creating so much texture in this painting, it's tough to simply paint around the edges of the message to reserve negative space for it. With masking fluid, you're free to paint, dab, and spatter over your message, and it will stay well-protected.

WHAT YOU'LL NEED

Watercolor card (If you can't find watercolor greeting cards, simply find a nice envelope and cut a piece of watercolor paper to fit)

Washi tape

Masking fluid

Fine brush (for use with masking fluid only)

Watercolor paints (several light blues)

No. 2 round brush

Tissue paper

1 Tape the edges of your card with washi tape. When working with watercolor, it helps to tape down a paper surface so it won't warp. I secured the watercolor card to the piece of cardboard that came in the pack. The washi tape also leaves a nice, clean border that will frame the watercolor texture.

Put a bit of masking fluid in a palette or a small dish. I like to use dedicated containers for fussy mediums like masking fluid and adhesive so they stay pure and don't get mixed up with paint.

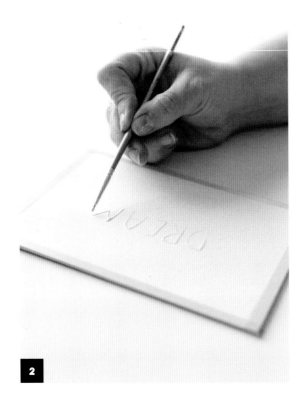

2

DON'T USE YOUR FAVORITE BRUSH TO APPLY MASKING FLUID!

– – –

If you do, it will never be the same. You can also apply masking fluid with a dip pen or silicone tools. Yes, they're easier to clean, but I still prefer a brush because of the look and feel of its stroke. For more information about masking fluid, see page 105.

3

2 Using a fine brush, paint your secret message on the card.

3 Let your message dry completely. The masking fluid will be hard to see at this point, especially if you're using clear masking fluid (as shown here). Note that some masking fluids have a yellow, gray, or blue tint, which makes them easier to see on a white surface.

4 Paint over your message. To make a soft, serene cloud scene, I'm using light blues. The paint looks pretty vibrant when it's wet, but it will dry much lighter.

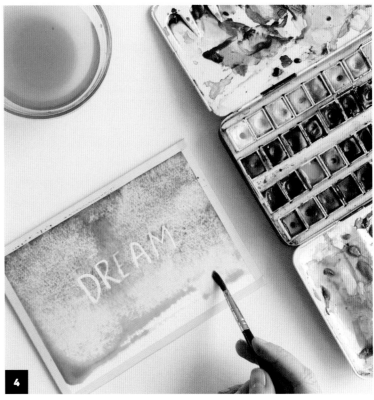

4

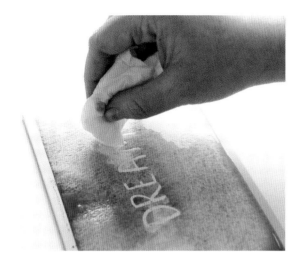

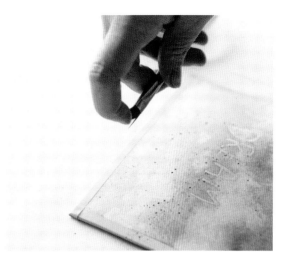

5 While the paint is still wet, dab areas with tissue paper (see page 38) to lift paint and create soft clouds.

6 Feel free to add a touch of blue or even iridescent spatter to your clouds. This will give your painting an ethereal vibe.

7 Once the paint has dried completely, remove the masking fluid and washi tape, place your piece of art in an envelope, and send it to a friend. To make this gift interactive, send the painting with the masking fluid still on, so your friend can remove it to reveal the message. There's something so satisfying about lifting masking fluid—your friend will surely enjoy it!

VARIATIONS

- - -

Try this technique with all kinds of textures or skies. I chose a dreamy theme for this project, but puffy clouds, lightning storms, and water-color galaxies are amazing options as well.

4

CELESTIAL SKIES

- - - - - -

Painting the universe has been a special part of my path as an artist. Not only has this subject helped me connect with my spiritual side but it has also given me the flexibility to experiment with all kinds of mixed media and watercolors. In fact, I would say painting the cosmos is the starting point of all the ideas that eventually turned into this very book. Textures from beyond and colorful planets are great inspiration for anyone experimenting with paint mediums. The universe is vast and mysterious; watercolor is a beautiful medium to represent these characteristics.

PHASES OF THE MOON

Painting the phases of the moon is very therapeutic. These graphic representations have been painted by artists through the ages, and it's no mystery why. We're fascinated by what we see above. The daily changes in the moon's appearance from Earth remind us that everything is cyclical. We're in constant movement.

The moon's phases, first and foremost, refer to the astronomical positioning of the moon in relation to the sun and the earth. But these phases also take on philosophical meanings as we relate the cycles of the moon to our experiences here on Earth. The new moon occurs when the moon is between the sun and the earth. Mystical interpretations of this cycle suggest this is a time for new beginnings and a time to refresh dreams.

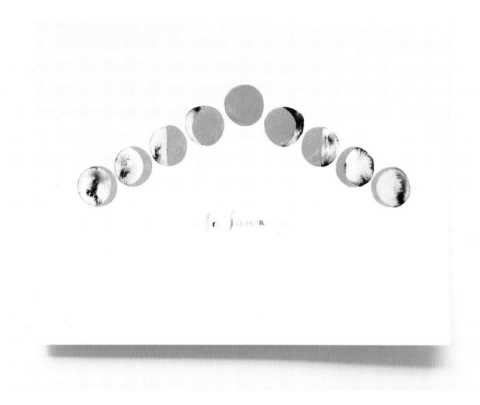

THE MOON'S PHASES
— — —

New moon

Waxing crescent

First quarter

Waxing gibbous

Full moon

Waning gibbous

Third quarter

Waning crescent

There are many ways to interpret the moon's phases graphically; as an artist it is your mission to take hints from nature and make creations of your own. Here are a couple of outline drawings you can use as inspiration. For full-sized versions, see page 133.

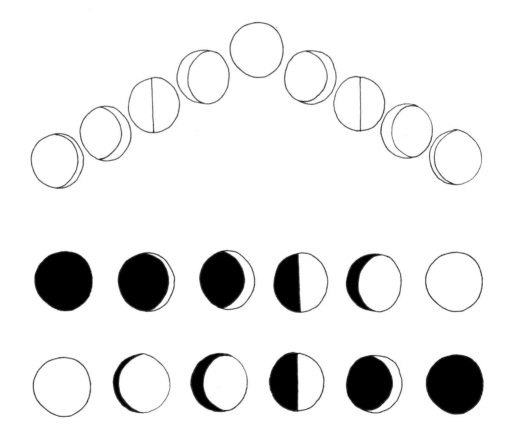

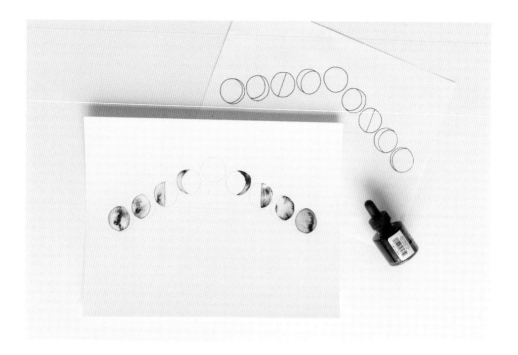

1 I like this chevron-shaped composition for a lunar phase, and I want to create a simple and elegant piece, so I'm going with black and a metallic paint. Start by filling out these sections of the moon with clean water. While the puddle is still wet, using a brush, add small drops of black India ink (this is the same effect created on page 39 of our experiments). You could also play with different textures; for example, a mid-value black watercolor wash with sprinkles of salt, or maybe spattered with alcohol or bleach. Whatever calls you. Let dry.

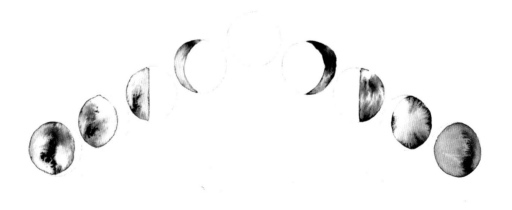

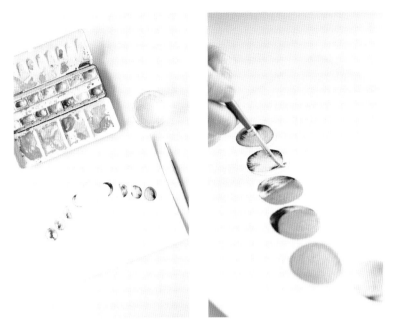

2 Once the black paint has dried completely, go in with a metallic watercolor to paint in the remaining lunar areas. I'm using watercolor from my Kremer Pigmente pan set, but you could also do this with delicate glitter or gold dust, or metallic acrylic paint or ink. Let dry.

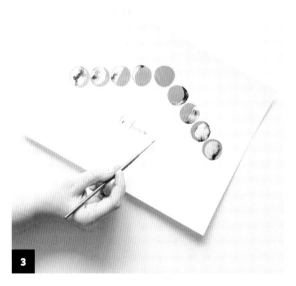

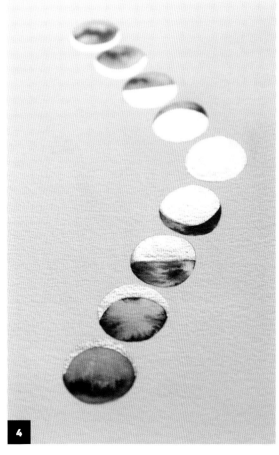

3 Feel free to decorate with lettering at the bottom. This could be a gift if you write a name in delicate calligraphy, too!

4 Once the metallic paint dries completely, its true level of shine will be visible.

CONSTELLATIONS & COSMIC TEXTURES

In this activity I focus on two elements: constellation formations while painting a cosmic texture. This galactic texture can vary depending on your color scheme and mixed-media elements.

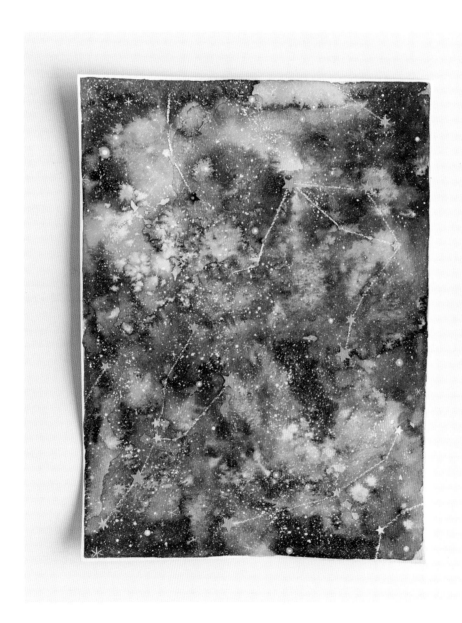

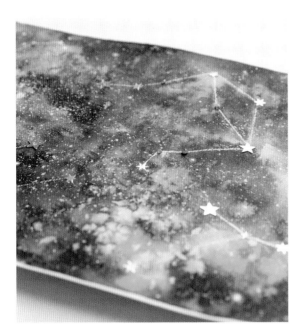

Constellations are a fun way to add an interesting motif to your interstellar artwork. Here are reference images of common constellation formations we know in reference to zodiac signs.

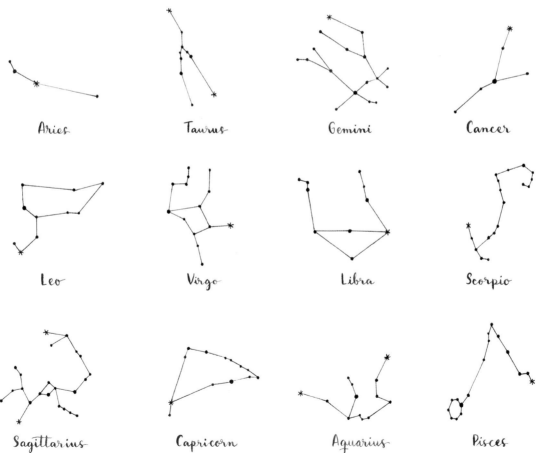

Aries

Taurus

Gemini

Cancer

Leo

Virgo

Libra

Scorpio

Sagittarius

Capricorn

Aquarius

Pisces

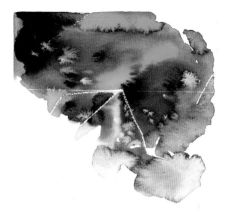

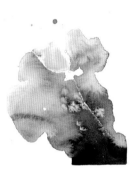

1 Choose a few constellations to use as a reference. You could also make up shapes and just have fun with this. But I think replicating actual constellations adds something special to these art pieces. Draw small circles with a pencil where each star will be, then connect the dots! Observe the way the constellations in your reference image connect. Using a clear wax crayon or a white crayon (sharpen your crayon for thin lines), draw straight lines from dot to dot. The lines will be invisible at this point, similar to our last experiment (see page 61).

2 Now, paint loose blobs of color. Use your favorite experiments from Experimenting with Mixed Media (page 34) to create interesting textures. Using salt is a great way to mimic tiny bursts. In the top left corner, I'm using indigo mixed with some blues from my pan set and a touch of juniper green in liquid watercolor form. These tones are great for vibrancy. In the bottom area, I'm adding a touch of magenta. Feel free to play around with neon watercolors, too. See how the wax shields water and your lines begin to appear!

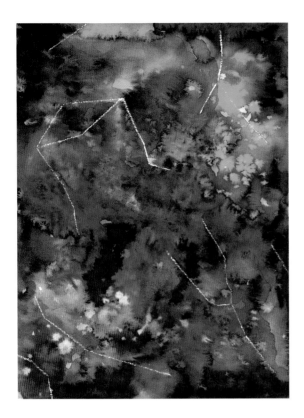

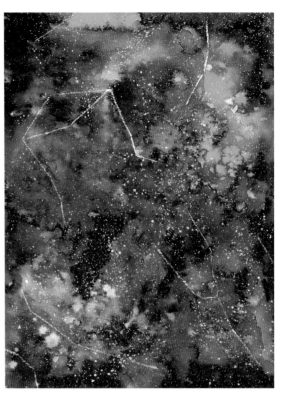

3 Continue painting around your paper, overlapping sections of watercolor with mixed media. You can't go wrong if you stick to mostly blue tones, although I like to add violet or magenta. I'm also adding touches of neon watercolor.

4 Once the watercolor paint has completely dried, go in with some watered-down white ink (gouache or acrylic could also work) and spatter around the page to create mini stars. The best brush to use for spatter is a large flat brush, or even a toothbrush.

5 Now, add extra star details using concentrated white ink to make the stars pop.

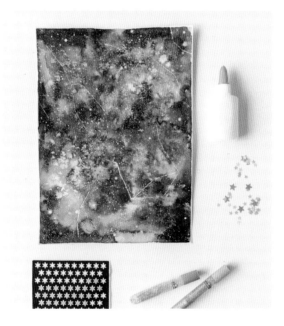
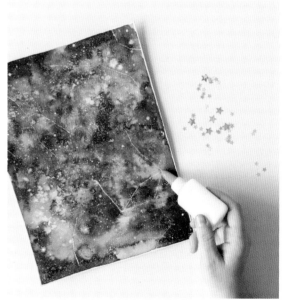

6 Embellish your constellation stars: There are so many details you can add to the intersection of each constellation point! I'm using star confetti, glitter glue, and tiny stickers.

7 To add confetti, place small dots of glue on selected points. You only need a tiny amount. Be careful! This can get messy.

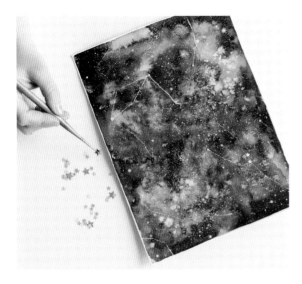

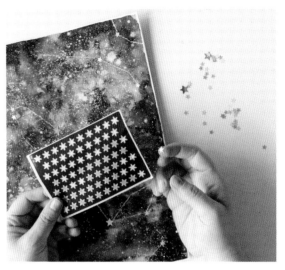

8 Delicately position the tiny stars in place. Use a brush or tweezers to handle them.

9 Now, add some stickers. Using a variety of craft supplies will add a layer of interest to your work. I found these super tiny silver stars in my studio and this is the perfect opportunity to use them!

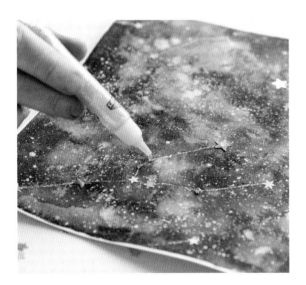

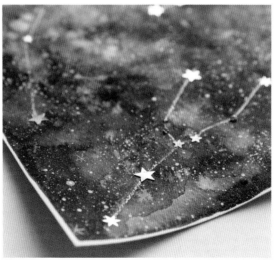

10 Carefully add dots of glitter glue to remaining points. When we look at the sky, it is apparent that some stars shine brighter than others. This is why it's only natural that your artistic stars will vary in shapes and sizes, too.

A detail of the final masterpiece!

SUNS & PLANETS

One reason I love painting planets and outer space is the abstract nature of each texture within simple geometric shapes. Watercolor is truly the star while creating these magnificent textures, especially when mixed with different mediums, like the ones we've been using throughout this book.

To create this activity, you'll need to have completed the mixed-media experiments on page 34, or create them now with the planets in mind. I love this activity because it's also a way of upcycling watercolor tests to create a beautiful piece of art.

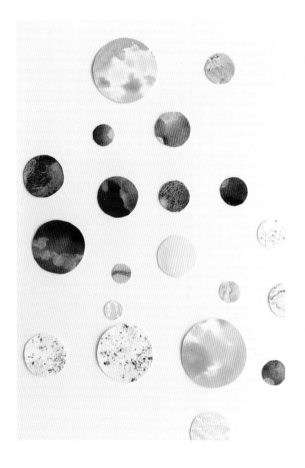

LET YOUR IMAGINATION TAKE YOU ON A COSMIC JOURNEY

– – –

Observe the experiments on pages 34 to 45 closely. Do any remind you of a planet? Maybe a green and blue experiment might look like planet Earth, or experiments with warmer tones can work for planets like Mercury or Mars. You don't have to be too literal, and these can be fantasy planets, but it's also good creative practice to observe and see whether your past experiments remind you of anything. It's fun to play and it encourages ideas for future projects.

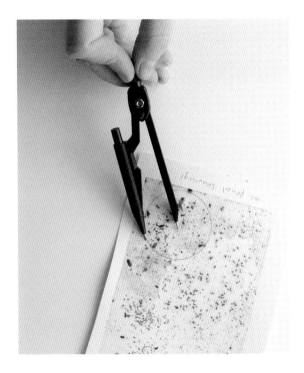

1 Cut some of your favorite mixed-media experiments into individual pieces so they're easier to manipulate. Using any tracing tool, draw circles of different sizes over your experiments. Choose the most interesting sections where you discovered striking effects. You can be as specific as you like here, either tracing random sizes or trying to be scientifically accurate with proportions. This is totally up to you!

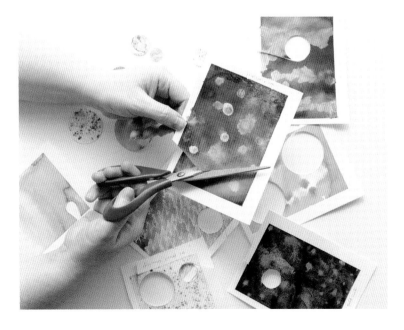

2 Using sharp scissors, cut out your circular shapes. Ta-dah! Your planets are ready. Think of all the possible canvases you can combine with these planets.

OUTER-SPACE COLLAGE

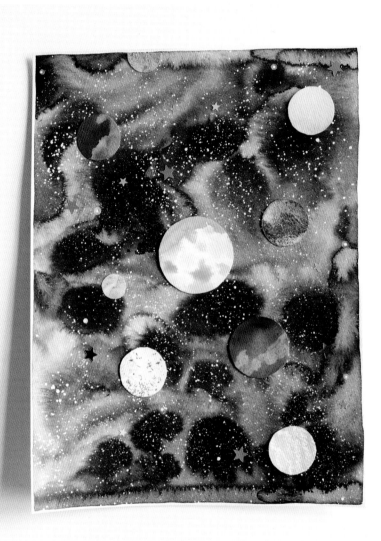

This is a great way to mesh your previous projects! There are many possible combinations waiting to happen. Each of the options we explore in this section look so different! Try any or all of these background options to create an amazing solar system using your planet cutouts.

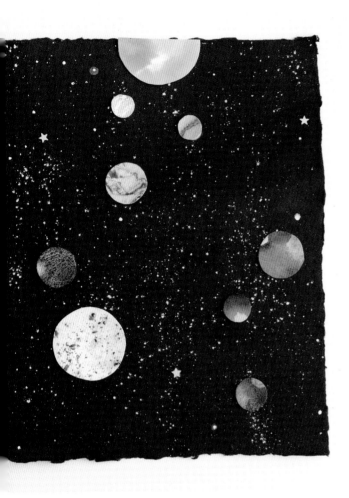

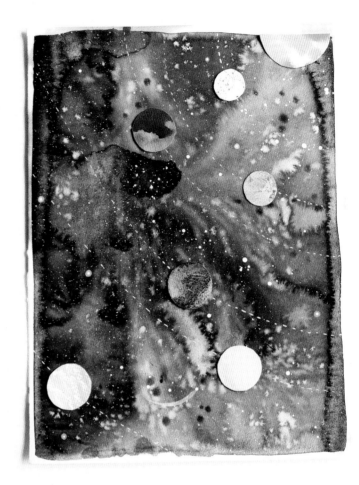

WHAT YOU'LL NEED

- - -

A dark background (see page 84 for options)

Experiments from chapter 2 to upcycle

Scissors

Glue or any adhesive medium

Compass or tracing tool to draw circles

Options for details: white or metallic paint

Backgrounds

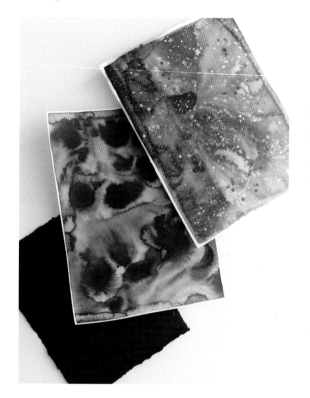

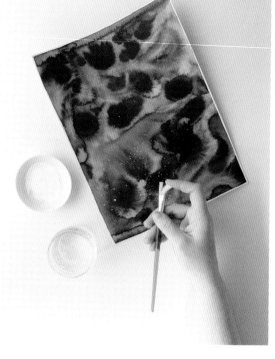

1 First, we need a dark background for our canvas. Here are a few options:

Thick black paper. This is a beautiful piece of hand-made black watercolor paper a student gave me. I love how deep the color is and I think it will make a great contrast next to our watercolor planets.

Mysterious black holes. Using the Ink Over Water method (see page 36), create a large version of black India ink on water by filling an entire watercolor paper with this effect.

Wet-on-wet technique. Using a wet-on-wet technique, fill an entire watercolor paper with a mix of different blues. I'm using indigo and Cascade Green. You can also add salt, bleach, alcohol, or any of the mixed-media techniques you like to this effect. This is a simpler version of the background on page 74 for Constellations.

2 Add a touch of white spatter to any of these backgrounds to create an extra level of interest. To add stars simply water down a bit of white ink, gouache, or acrylic paint and use a flat brush or toothbrush to spatter paint using your finger against the brush. For smaller, more compact stars, place your brush close to the paper; for larger and widespread stars spatter your paint farther away from the paper. I like to play around and mix in all different sizes of stars to add dimension to the background.

Putting It All Together

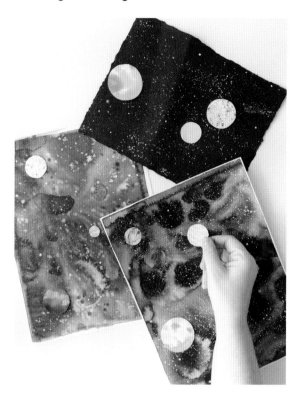

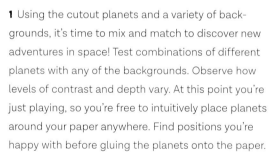

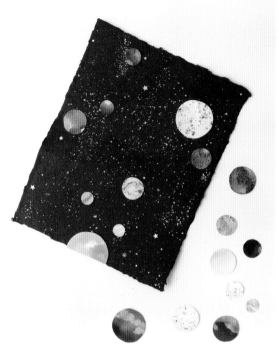

1 Using the cutout planets and a variety of backgrounds, it's time to mix and match to discover new adventures in space! Test combinations of different planets with any of the backgrounds. Observe how levels of contrast and depth vary. At this point you're just playing, so you're free to intuitively place planets around your paper anywhere. Find positions you're happy with before gluing the planets onto the paper.

2 Find a composition you like. I cut the big orange circle in half because it works well as a sun shape, as it appears on solar system charts sometimes.

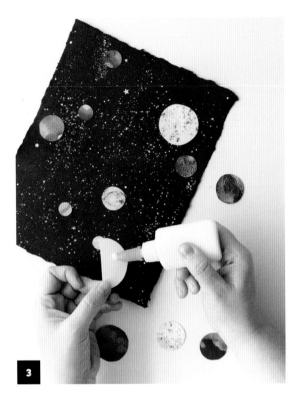

3 Flip over each circle, apply glue to the back, and paste the circles onto the background.

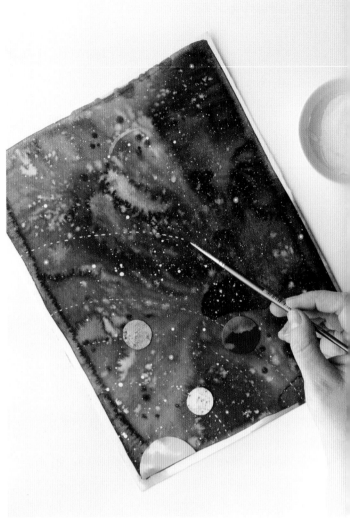

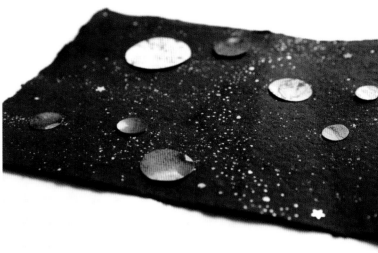

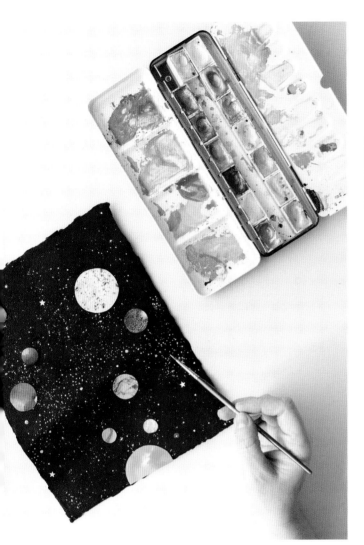

Now that you have a basic composition, add details. Here are some examples using the various options: paint larger stars in a variety of shapes; paint planet orbits or a meteor belt using white ink; paint gold or metallic dots; add tiny stars or specs of glitter.

5

GEMS & CRYSTALS

- - - - - -

I've enjoyed painting crystals and gems for many years now. There are a variety of ways to paint these beautiful earth objects as well as the many forms in which they can be found. Another great example of simple shapes and fascinating textures.

CRYSTAL SHAPES

There are three general categories I like to refer to when outlining gem or crystal drawings. As you may know, all kinds of precious stones and minerals come from the earth. Some in very raw form are later polished and cut, others are naturally shaped in interesting ways and can be admired because of their naturally occurring formations.

I represent the gems and crystals as outline drawings in the following ways:

• Rough minerals
• Gem cuts
• Natural crystal formations

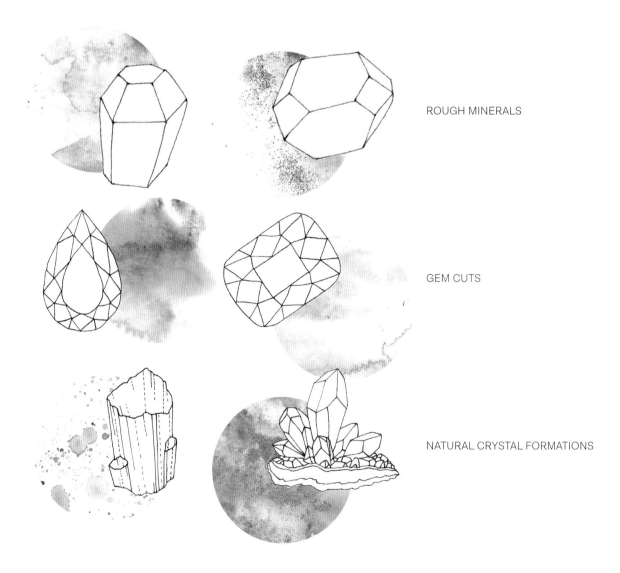

ROUGH MINERALS

GEM CUTS

NATURAL CRYSTAL FORMATIONS

POPULAR GEMSTONES

- - -

The following list offers examples to inspire you. As always, I recommend going to nature for further references. There are tons more shapes and styles to recreate!

- Agate
- Alexandrite
- Amethyst
- Aquamarine
- Aventurine
- Azurite
- Black onyx
- Bloodstone
- Cat's eye
- Citrine
- Diamond
- Emerald
- Fluorite
- Geode and geode structures
- Jasper

- Moonstone
- Obsidian
- Opal
- Pearl
- Peridot
- Quartz
- Ruby
- Sapphire
- Tanzanite
- Tiger's eye
- Topaz
- Tourmaline
- Turquoise
- Zircon

AMETHYST CLUSTER

Amethyst is a semiprecious stone, which glistens in a range of violet hues. It has been admired throughout the ages because of its beautiful color and spiritual properties. I chose this specific quartz to demonstrate just one way you can illustrate a crystal cluster, or any type of stone for that matter.

Although I don't use watercolor pencils in my personal art practice much, I do get asked about them frequently by students. On page 42 we experimented by sprinkling watercolor pencil shavings on water, but there's also a more traditional way to use them. This style of painting reminds me of coloring books when I was a kid, where I would activate the paper with water and color would magically appear.

For this amethyst, I choose to use light and dark blue, violet, and a touch of red. If you have a larger variety of purples, magentas, and blues, go ahead and use them! Watercolor markers would also be fun to try in a similar way.

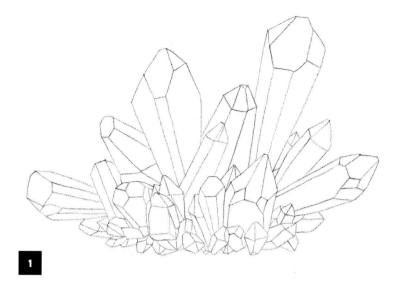

1 Begin by drawing the outline of a crystal shape using your violet-colored pencil. This will be the predominant tone in your final painting. Watercolor pencils don't erase easily, so be mindful of your drawing. You can use the drawing on page 92 or a photograph for reference. A quick Google search will pop up thousands of crystal clusters!

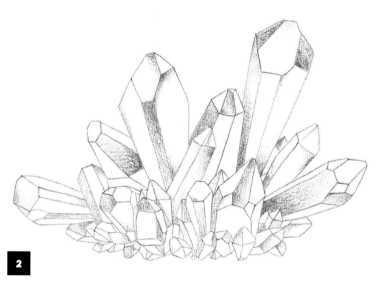

2 Select certain areas of your crystal and shade them with your dry watercolor pencils. It's important to keep some areas without shading to represent the walls of your shape, where light reflects the most; other areas can have just a touch of shading, whereas some will be darker and full of color. Being mindful of contrast is important if you are looking to achieve dimension and light reflection.

3 Once you've colored in your shape, brush water over your drawing one area at a time. Watercolor pencils will magically dissolve into a watercolor wash, leaving a trace of a scribble texture from the drawing. The areas you left empty will also be colored in. The outline of your drawing is enough to add a subtle touch of color.

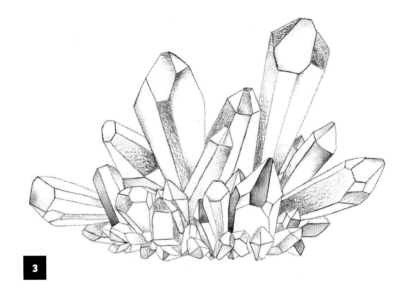

3

4 This step is important. Let each area dry before painting the neighboring area. Don't just add water to everything. Continue to keep the areas separate. This is how you achieve that beautiful blending outline around each wall of your crystal. Continue to add water to each section individually until you've filled them all.

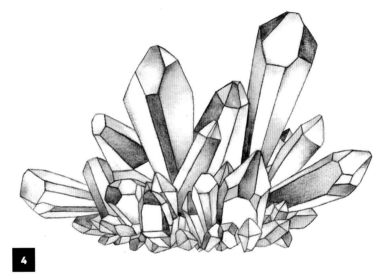

4

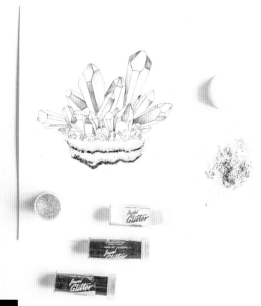

5 Now that your watercolor painting has dried, you can add an extra layer of glitz by embellishing with glitter along the bottom area of the cluster or cavity out of which the quartz is forming. Dilute a bit of glue with water (I like to water down glue so I can get a nice smooth area of adhesive) and just follow the bottom area of the cluster. Add any glitter you like! Wait for a few minutes and then shake out the excess glitter.

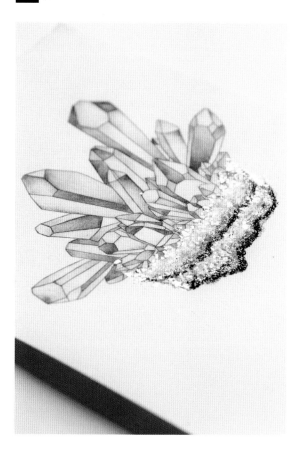

TIP

Save excess glitter on a sheet of paper under your project. Even if the different types of glitter end up mixed together, this can still work for a new project! I like to fold the piece of paper in the shape of an envelope and save it for something new later on.

GEMS & CRYSTALS

NATURAL EMERALD

Gemstones can be polished and cut into specific shapes; for example, a classic oval cut maximizes a diamond's shine. My favorite gemstones to paint are those in a more natural form, with uneven shapes and pieces of earth, untreated and raw. I enjoy using these types of gems as inspiration because they invite the use of diverse mixed media as well as integration of earth tones, such as ochre or burnt umber. These tones are personal favorites and I love how they mix with the vibrancy of crystals.

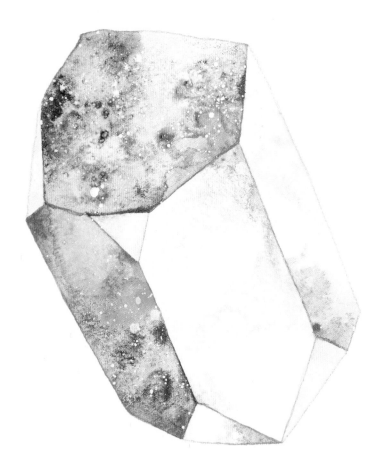

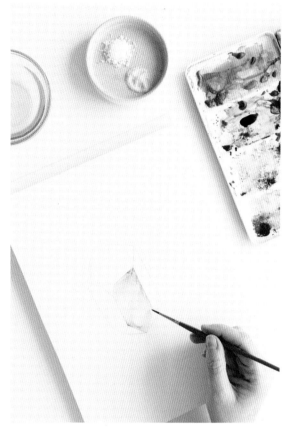

1 Begin with a simple drawing. You can use any of the outlines on page 101 for shape inspiration. I use hard H pencils for guides with my watercolor paintings because the lines they make are light and barely visible. It's very difficult to erase pencil markings once watercolor has been painted over them, so it's best to keep the drawing simple and clean.

2 Each section of this drawing will be painted at a different time to represent the different sides of the emerald. This first section represents the front of the gem, which I'm intentionally making quite transparent to represent a lighter area where light reflects off this side of the shape.

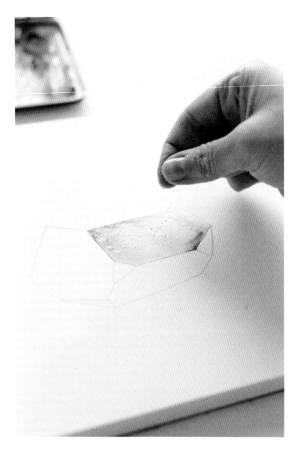

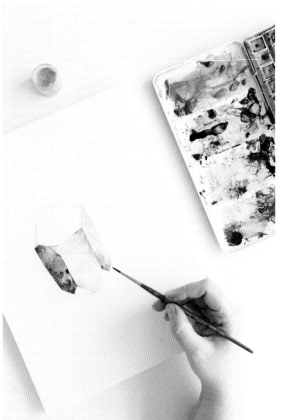

3 I'm using a mix of watercolors, including Cascade Green by Daniel Smith, which I'm in awe of because this specific type of paint has two pigments that separate on paper; with the right amount of water, you'll see olive green turning into a lovely shade of aquamarine. It's perfect for an emerald painting! While the paint is still wet, you can sprinkle a bit of salt on this area to enhance the texture.

4 With shapes like these, there's a bit of a waiting game. It's important to let each section dry completely before painting the one next to it. If you paint the next section immediately, your paint will bleed into the neighboring side and you'll lose the angled effect. Be patient!

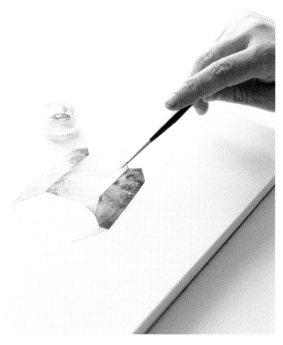

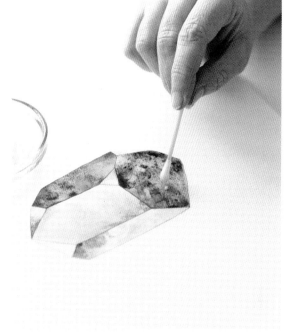

5 As each side dries, paint the surrounding areas. Be mindful of lighting and make sure to have plenty of variety when it comes to paint saturation and color value. You can also sprinkle a bit of fine glitter on selected areas for some interesting effects. These effects are subtle and best noticed in person, when the painting is in movement.

6 Proceed to paint more areas. I'm choosing to make this face of the gemstone darker and grittier, so in addition to my green and aqua color palette, I'm adding touches of earth tones to make this emerald look natural and raw. I'm also using a cotton swab with a bit of bleach (rubbing alcohol can also work) to add texture. Paint the remaining sides, alternating the lightness and darkness of the reflections.

VARIATIONS
– ● –

This simple gemstone is a great way to integrate many of the mixed-media experiments we did earlier (see pages 34–45). Try different colors, gem types, and crystal shapes. You can also use photography as a reference if you want to be more precise.

LOOSE & EXPERIMENTAL HEALING CRYSTALS

This style of painting crystals is more abstract and free. We're not necessarily aiming for a realistic look, or to depict shadow and light as with the previous activities. Instead, it's a fun way to play with textures and color using these shapes as a canvas. Make sure you've done the mixed-media experiments (see page 34 to 45) before diving in here!

For this activity, you'll need some masking fluid. I'm using a dark type of masking fluid so the lines are more visible. The fluid is dark but it will lift up in the same way a transparent fluid does. It just helps you see where you're painting. For more details, see page 105.

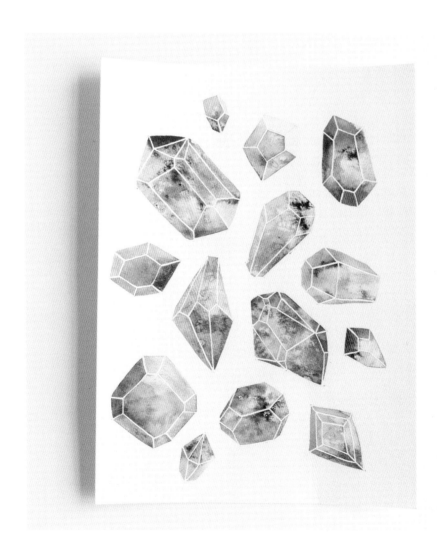

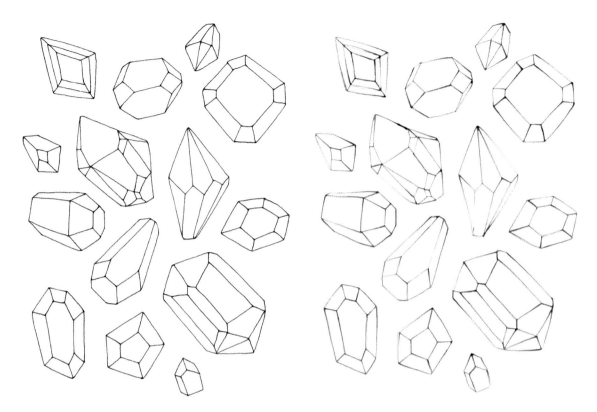

1 Draw various crystal shapes all around your water-color paper area. Be mindful with your pencil; it's important to remember that once watercolor has been painted over a pencil marking, it is very difficult to erase the marking. I created an outline template (see page 136) of the shapes I am using; you can copy these or make up any crystal shapes you like.

2 Once you have your drawing set up, using a thin brush, trace the outline of your crystals with masking fluid. Try to make these lines as thin as possible. Let the masking fluid dry completely. I would even wait a full hour just to be sure.

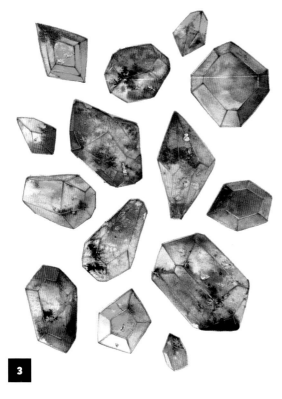

3 Now, use all your favorite effects from chapter 2 to fill out your shapes! Paint in the entire area of each crystal using watercolor and mixing in whatever feels right. Try ink, salt, or acetone to create interesting textures. I've added a few gold leaf flakes to some of the crystals. You don't have to worry about painting each individual area of the crystals separately; the masking fluid will serve as a divider when we lift it up later.

4 To add gold leaf flakes, pick up small pieces with your damp brush **(A)** and place each piece onto the wet watercolor **(B)**. The moistness of your painting will be enough to bind these delicate flakes to the paper. You could also mix in shimmery paints, fine glitter, or metallic ink.

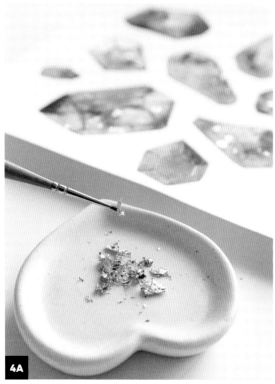

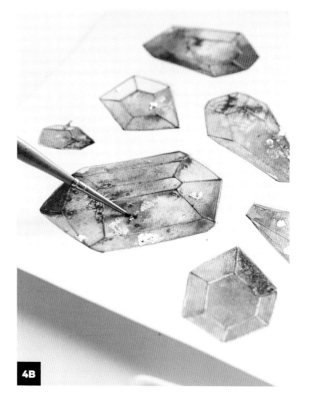

CREATIVE WATERCOLOR & MIXED MEDIA

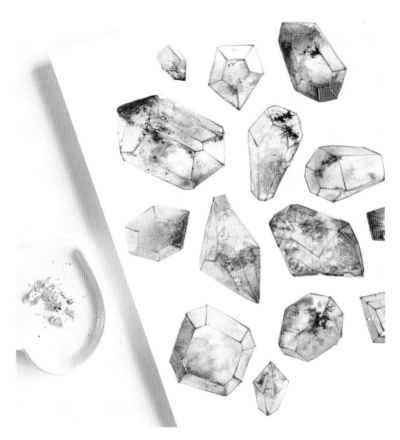

5 Let the paint dry completely. I know you're eager to reveal what your painting will look like without the masking fluid, but trust me, patience is a virtue here. If your paint or paper is even slightly wet, your masking fluid is likely to pick up a chunk of paper and ruin your painting!

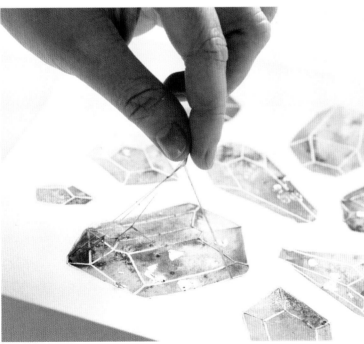

6 This is the best part! Now that your paint has dried, lift up your masking fluid. Rub your finger over the areas where you placed masking fluid, turning it into a rubbery substance that will easily lift up from the paper. Continue to peel it off. You can also use an eraser to help you lift certain areas.

7 With the masking fluid removed, erase any pencil lines that are still showing.

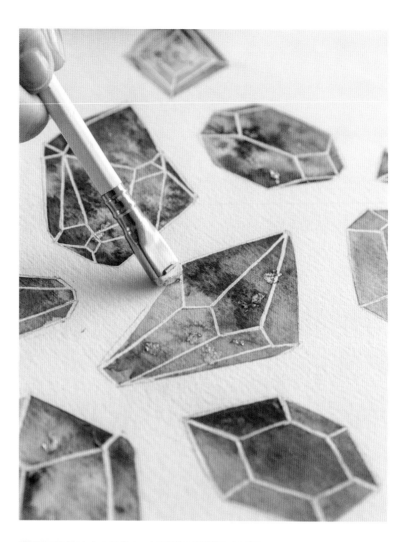

8 We have a beautiful healing crystal painting! To preserve paintings like this, spray a finishing medium over the painting to help protect specks of gold leaf, if used.

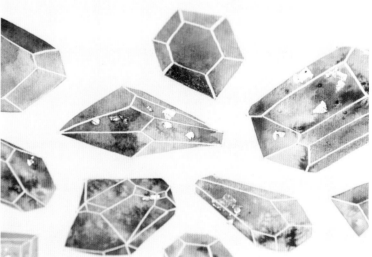

MASKING FLUID TIPS

- - -

Masking fluid is also known as liquid frisket.

- **Reserve masking fluid use for difficult textures or extremely small spaces.** For most occasions, it's easier to simply paint around a specific area than to mask large shapes.

- **Use a brush that's good enough but *not* your favorite brush.** Your brush will *not* go back to normal after you use it to apply masking fluid. I like to have a few brushes in my studio that I use specifically for these types of mediums.

- When using masking fluid, **rinse the brush with water constantly**. This fluid dries quickly on your brush, which makes it difficult to remove. Dry the brush with paper or cloth before picking up more of the medium.

- **Additional tools** to use when applying masking fluid include a silicone rubber brush, a fine line applicator bottle, a needle-tip applicator, and some dip-pen nibs.

- For extremely fine work, **masking fluid markers** are also an option.

- **It's possible to use masking fluid over previously painted, dry areas**—but keep in mind that the latex will pick up some of the pigment you had applied.

- **Always use masking fluid on a dry surface.** Always wait for masking fluid to dry completely before painting over the masked area. The same goes for the paint before lifting up the masking fluid.

- **Always be gentle when removing masking fluid** to avoid ripping the paper.

- **Remove masking fluid once paint and paper have dried, but don't wait too long.** The amount of time you have depends on a number of factors, including brand, paper type, and humidity. If masking fluid is left on paper too long, it becomes extremely difficult to remove.

- **A favorite tip I picked up from a student is to use essential oils to remove dry masking fluid from paintbrushes.** Lemon is my go-to. I've heard that petroleum jelly also does the trick!

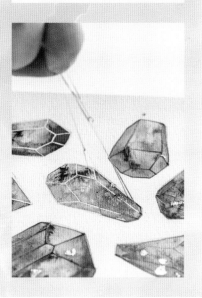

BIRTHSTONE CHART

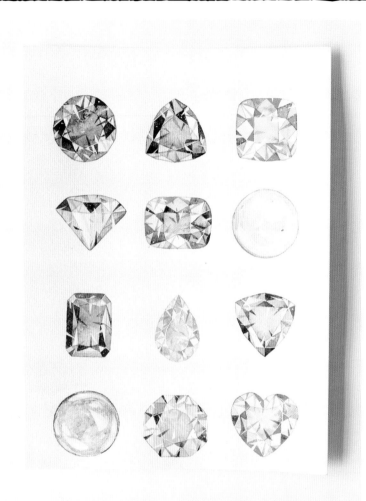

TRADITIONAL BIRTHSTONES

Some months have more than one option; the following is the traditional list:

January: Garnet
February: Amethyst
March: Aquamarine
or bloodstone
April: Diamond
May: Emerald
June: Alexandrite, pearl,
or moonstone
July: Ruby
August: Peridot
September: Sapphire
October: Pink tourmaline
or opal
November: Topaz or citrine
December: Blue topaz,
tanzanite, or turquoise

You may already know about birthstones, but if this concept is new to you, it refers to a specific precious or semiprecious stone assigned to each month of the year. We all have a birthstone! They're generally presented in the form of cut gems because they make good birthday presents as jewelry.

For our final gem project we're going to paint a birthstone chart. This makes a great poster, or you may even choose to concentrate on one specific month to give as a birthday card.

WHAT YOU'LL NEED

- - -

Watercolor paper

Variety of watercolor paints

Thin and liner brushes

White ink, gouache
 or acrylic

Optional gold paint

Optional reference image
 of gem outlines

POPULAR GEM CUTS

- - -

Baguette

Briolette

Emerald

French cut

Heart shape

Octagon

Oval

Pear or Drop

Princess

Rose

Round

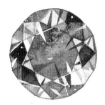

January – GARNET

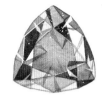

February – AMETHYST

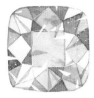

March – AQUAMARINE

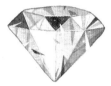

April – DIAMOND

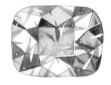

May – EMERALD

June – PEARL

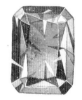

July – RUBY

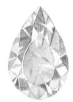

August – PERIDOT

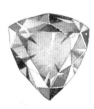

September – SAPPHIRE

October – OPAL

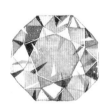

November – CITRINE

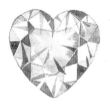

December – BLUE TOPAZ

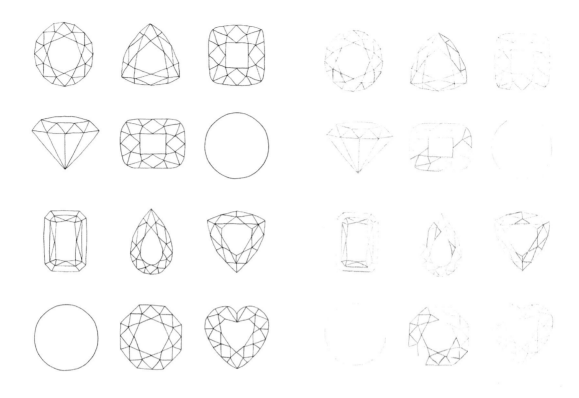

1 In addition to the gem colors noted above, I have created a guide to different gem cuts for you to use as a reference (see page 90).

2 Begin by making a pencil outline of these shapes.

3 Paint an initial layer of watered-down paint, depending on the base color of each gem. Use a ratio of 90 percent water to 10 percent paint for this step. Make sure your paint is quite transparent as it is your first layer. You will paint many layers over this and you should still be able to see your pencil markings perfectly. I'm leaving the opal blank for this first step because we will be using a wet-on-wet technique for that stone.

4 Once your first layer of transparent paint has dried, begin to paint selected areas of your gems with a second layer of paint. Mixing in touches of similar colors in each gem is encouraged to add some interesting depth. For example, add touches of pink paint to your red ruby or yellow to your lime green peridot. It's important to paint scattered areas of your gems to avoid bleeding between the watercolor washes. Use a thin brush for this project.

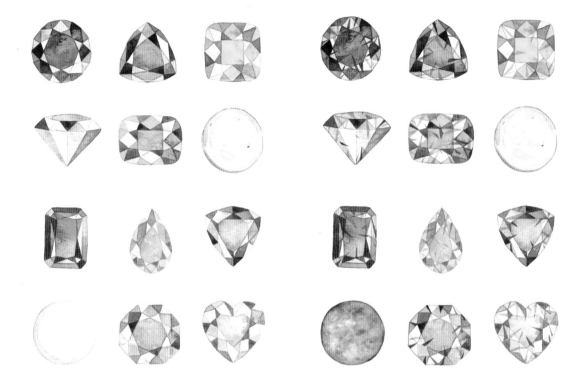

5 Now, go in with deeper values of each color and continue to paint selected areas. This will create a realistic effect of light reflecting and shadows darkening. It helps to find pictures or observe real-life gems for color and shading reference. There are subtle changes in color depending on the light and gem properties. Notice how the citrine is mostly a yellow-orange but has hints of dark umber and browns in opaque areas. I also added a subtle shadow effect on the opal.

6 To create a crystalized effect, wait for past layers to dry, then paint tiny triangles in corresponding color tones on each gem. For the opal, paint a layer of water and mix in multicolored wet paint around the circle. Let the paint dry.

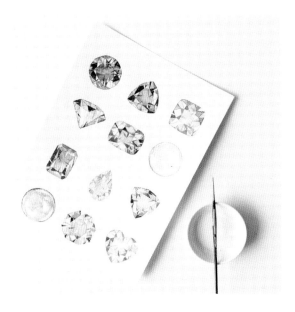

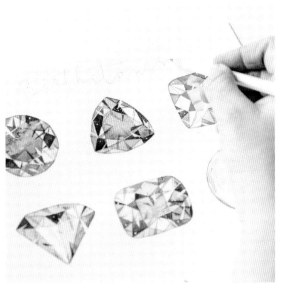

7 Add shimmery and reflective details with white ink. I love Copic white ink, but any brand will work. White gouache or a white gel pen also work.

8 Leave your chart as is, or add optional lettering.

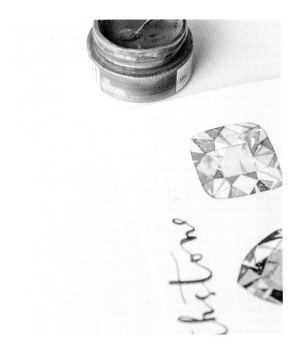

9 For a final touch, use elegant handwriting and gold ink to letter the word "Birthstones" as a title for your chart.

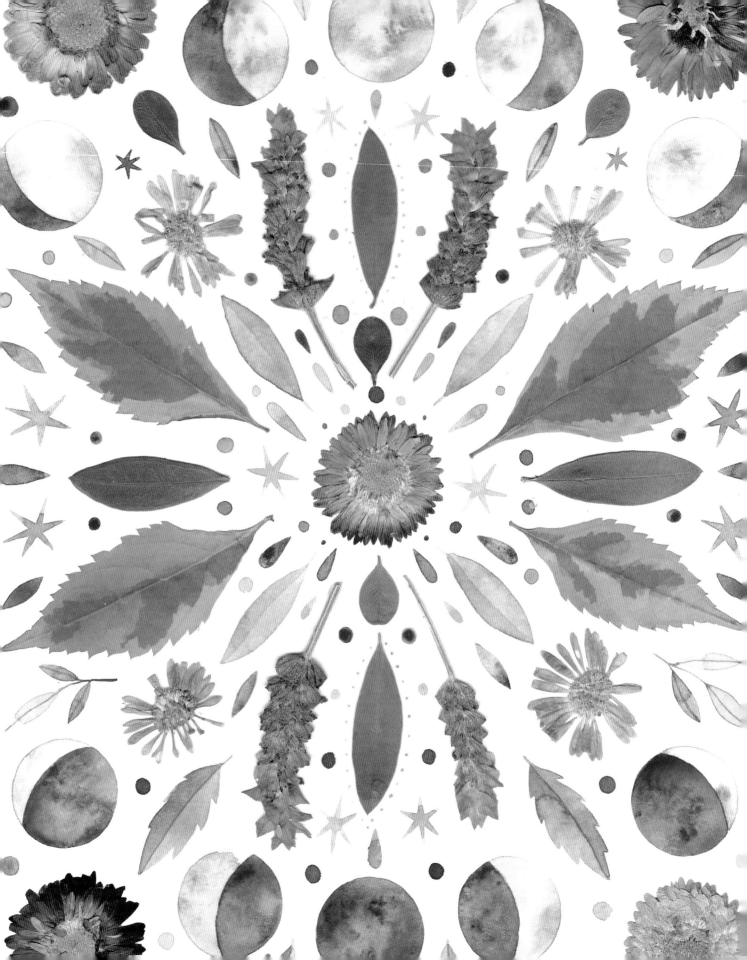

6
EARTH & SACRED GEOMETRY

- - - - - -

This chapter uses natural elements to create mandala-like symmetrical compositions. These earthy pieces of art are perfect for anyone who enjoys wandering in the woods or a field. The word *mandala* simply means "circle" in Sanskrit. There are many types of mandalas—some are part of a spiritual practice while others are more playful and serve the purpose of relaxing the mind. In essence, mandalas consist of repetitive shapes arranged in a symmetrical pattern that expand concentrically.

ANCIENT SHAPES

I frequently visit a family friend's hacienda in rural Mexico, where we spend days cooking, taking long walks, watching sunrises, feeding donkeys, and picking wildflowers to make centerpieces for the table. A few years back I began collecting these wildflowers and pressing them to keep as memories of these days in the countryside. One Sunday night, after returning from the hacienda, I began playing with these pressed flowers. I naturally began arranging them in organized geometric and concentric patterns. I realized that, after arranging these leaves and flowers, I was making an organic form of mandala, and that I could add details to these arrangements by painting watercolor motifs around the natural compositions.

At the same time, I began to grow immensely interested in sacred geometry. Sacred geometry refers to a series of universal shapes and patterns that compose everything in our reality. These proportions have been used throughout the ages by mathematicians, architects, scientists, alchemists, and of course, artists, most famously Leonardo da Vinci. These shapes have been found in all areas of life, from ancient temples to patterns in nature.

Sacred geometry is understood to be the universal language of all things. The proportions are embedded within us and live around us.

To truly connect with the magic behind these ancient shapes, it isn't enough to simply observe these figures—one must experience drawing them as well. It is a transformational experience. Adding personal artistic styles to geometrical shapes becomes a full human experience because your brain is using both sides. While satisfying mathematical precision is experienced in the drawing phase, creative expression and artistic exploration are experienced in the decoration phase. While decorating these shapes, you'll begin to discover different patterns, and each time you paint a sacred geometry shape, you'll discover new ways of enhancing them.

In this book I specifically demonstrate how to draw a Seed of Life, a fundamental shape and starting point of all other sacred geometry designs. It's a great place to start if you're curious about exploring this topic.

In the following pages we decorate this Seed of Life and, ultimately, integrate natural elements to create an organic mandala-like composition.

It's important to mention that painting these symmetrical shapes is both extremely relaxing and therapeutic. Time magically dissolves during this process.

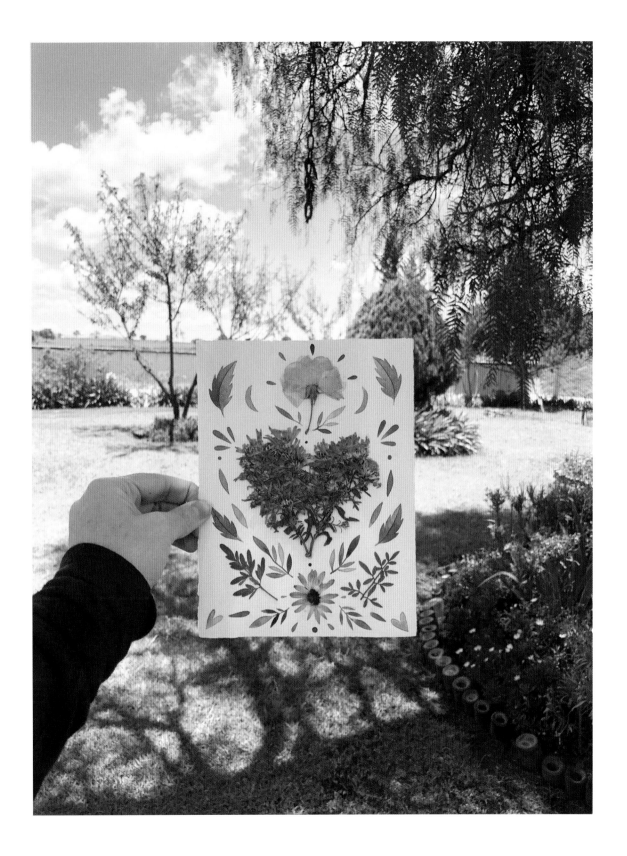

THE SEED OF LIFE

At the center of every sacred geometry drawing is a circle. The circle represents infinity because it has no beginning and no end. For the circle to be able to create a point, it must duplicate, therefore creating an intersection. The beginning of the circle's duplication is known as the first stage of creation for all other shapes that exist. The seed of life is simply this circle continuing to replicate itself and overlapping at each intersection until a perfect seven-circle composition is created and all circles lock perfectly.

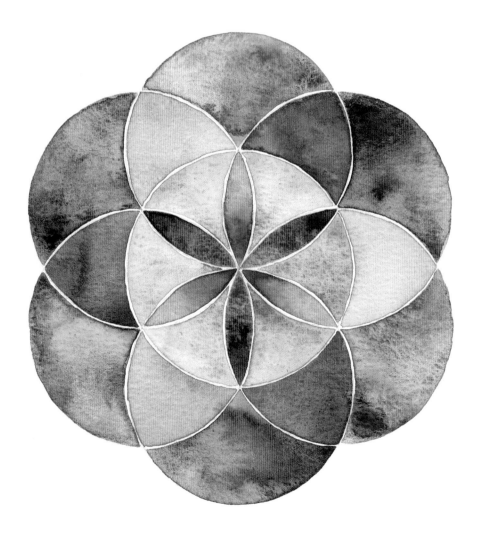

Drawing the Seed of Life

1 You'll need a piece of paper and a compass. The size of the circle must stay exactly the same throughout the process. Draw your first circle in the center of your paper.

2 Now, using the same opening of the compass, direct the pointy tip to any area of the circumference of the original circle. Draw a circle around that point. You will now have two interlocking circles. The drawing at this point is actually a sacred geometry shape itself called a *vesica piscis*. The dot in this drawing indicates where you will set your compass point and the three arrows represent where your pencil side of the compass will be.

3 Once you have two circles, place your compass tip on the next intersection and proceed to draw a circle around that point. You will now have three circles.

4 Continue tracing circles around your initial circle—seven in total—using the marked dot as a reference for the center point of each following circle.

4A

4B

4C

4D

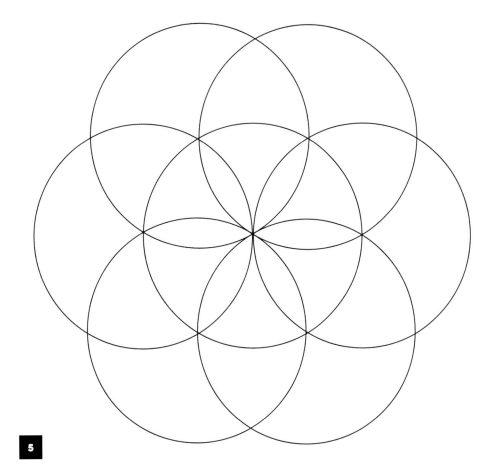

5

5 You've now drawn a Seed of Life!

Painting the Seed of Life

Now for my favorite part—enhancing this drawing with watercolor!

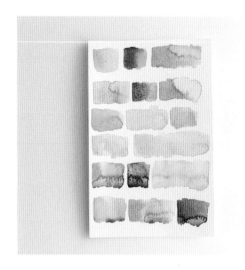

1 Before I start a project like this, I like to choose my color palette. I always have scrap watercolor paper nearby to swatch the colors I want to use, depending on the mood I want to create. Because we're painting a Seed of Life and will later enhance the art with natural flowers and leaves (see page 124), I chose earth tones to convey a grounded feeling.

2 Once your color choice is established, it's easy to paint the different sections. As you can see, the pencil markings for my Seed of Life are quite light. I recommend using subtle traces when painting with watercolors; if your paint happens to overlay the pencil markings they will be difficult to erase. Keep in mind watercolor paint is translucent and there is a certain amount of refinement required. Begin by painting your first sections of the Seed of Life drawing. I am using a simple gradient of ochre with green for the first section.

3 Here I'm switching colors to the warmer tones of the palette. I decided to skip three petals in my inner concentric design to have some variation in this part of the drawing.

4 Wait for the inner area to dry a bit before painting the areas surrounding the inner petals. The idea here is to paint right next to the pencil markings but not over them. This will leave a delicate white line between your shapes and will also avoid bleeding, in case some of the neighboring areas are still wet. I used a watercolor called Cascade Green by Daniel Smith for these greenish sections. I love this specific type of paint because pigments separate and you get an interesting grainy texture within your watercolor wash.

4

5 Now I'm painting the outer petals. Just as in steps 1 and 2, I alternate colors by skipping a petal. I'm using very simple gradients here. With watercolor it's easy to blend colors if you have the right amount of moistness in the wash. You can even paint one section using one color and just add a touch of another color at the tip of the petal and let it blend in naturally.

6 For the final outer edge petals I use the same technique, using colors from my chosen palette and softly blending in various tones on the tips of the petals. Once all your sections have dried completely, erase the pencil markings.

Keep in mind that part of the fun while painting sacred geometry is discovering patterns for yourself, so you can try it this way or do something totally different with colors and pattern recognition. In fact, you can paint a seed of life many ways, or even continue a more organic hand-drawn mandala around the initial shape. It's all about playing and having fun while you enhance your drawing.

5

6

Variation: Metallic on Black

Now that you know how to create a Seed of Life, you can continue with this pattern, expanding the circles around and around with your compass. You can create different compositions, like a Flower of Life or different symmetrical patterns using the same method.

A fun idea is to use metallic or iridescent watercolor paint on black paper. This will create a beautiful sacred geometry drawing that shimmers with movement.

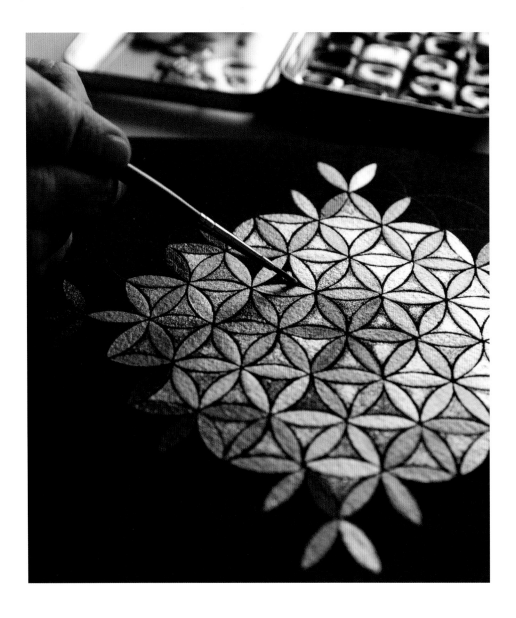

1

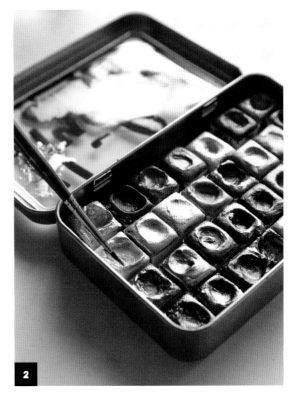

2

3

1 If you can find black watercolor paper, that's great! I like the brand I'm using here, Stonehenge Aqua Coldpress Black Legion Paper, or you can simply paint a full background with black watercolor paint, similar to what we did on page 39 with metallic paint swatching.

2 Once you trace the design using a compass, paint the different sections. Choosing the colors to use in each area is the fun part! I'm using my HydraColour iridescent watercolors. I chose to paint the thinner petals with colors following a rainbow pattern and left the extra areas black to fill later with HydraColour's Diamond Dust.

3 This is a fun variation of a sacred geometry activity that simply expands your drawing and uses different mediums.

PRESSING FLOWERS & LEAVES

Ah, to gather flowers! This is an activity I enjoy immensely—so much so that I collected more than 100 different flowers and pressed them to add unique details to every wedding invitation I sent to my guests. I've become fascinated with pressing flowers and leaves and all the different compositions. Pressing flowers is actually quite simple, but as you experiment with different types of flowers you will notice some take more time than others. I think good options to start with are daisies or wildflowers. They have less density and moisture than larger flowers, such as roses or carnations.

1

2

3

1 Gather fresh, clean, dry flowers. It's best to do this on a sunny day so the flowers are less likely to have droplets of rain or dew on them. If you're collecting daisies, cut the stems as close as you can to the bud so you can lay the flower heads flat. I also like to press leaves with my flowers because they're great for creating mandala compositions.

2 Gather a heavy book and a sheet of parchment paper. Line the pages of the book with the parchment paper. Place your flowers face-down inside the book. Close the book and place extra weight on top.

3 Wait a couple of weeks. When you open the book, your flowers will have pressed and dried!

DECORATING PRESSED BOTANICALS

I like to add simple gold details to some flowers. This gives handmade projects an extra touch of authenticity and craftwork. Details like these won't be too over the top—just enough to notice when the light hits your artwork the right way.

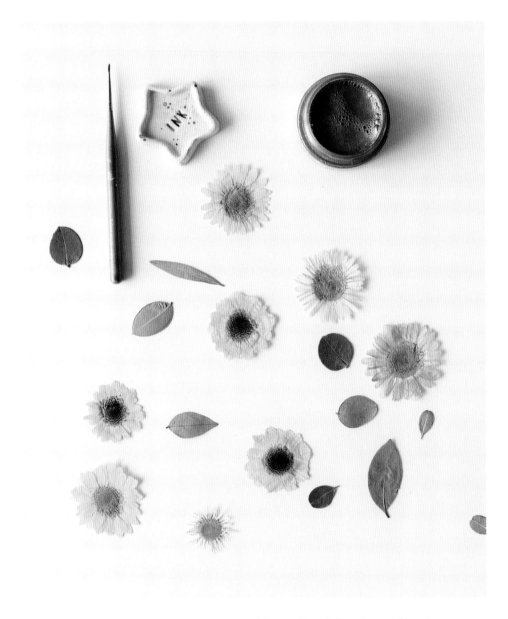

1 You'll need pressed leaves and flowers, gold ink (or acrylic paint), and a small brush.

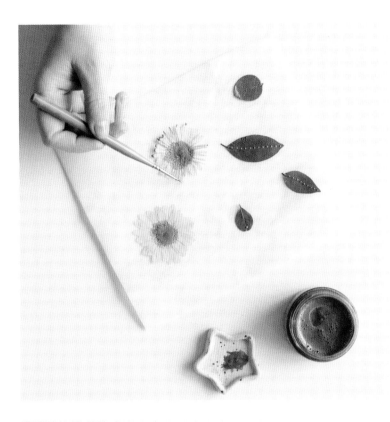

2 Gently decorate the tips of your flowers and details on the leaves with the ink. Try not to go too over the top here—a little shine goes a long way.

3 Let dry for a couple of hours.

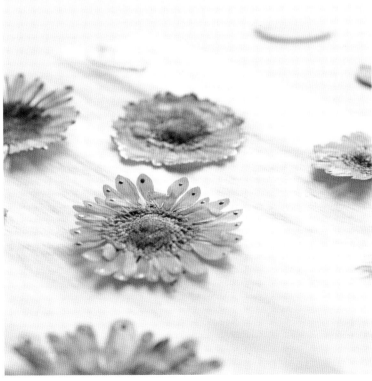

ULTIMATE MIXED-MEDIA MANDALA MASTERPIECE

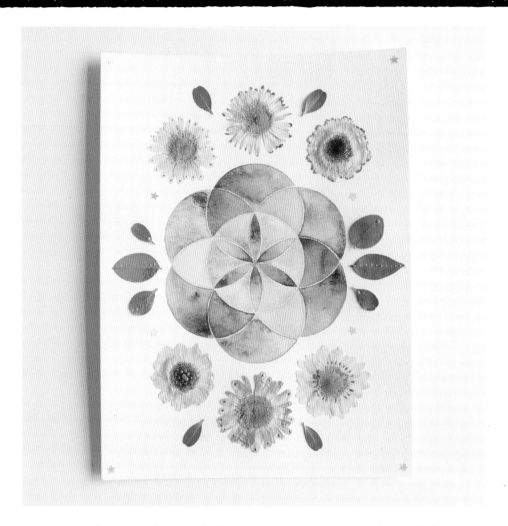

Now that we have a lovely Seed of Life painting (see page 120) and beautifully embellished pressed flowers (page 124), we have all the parts we need to create a final mandala masterpiece.

The center of our symmetrical arrangement will be the Seed of Life we created on page 116. This is the perfect starting point around which to arrange your organic botanicals.

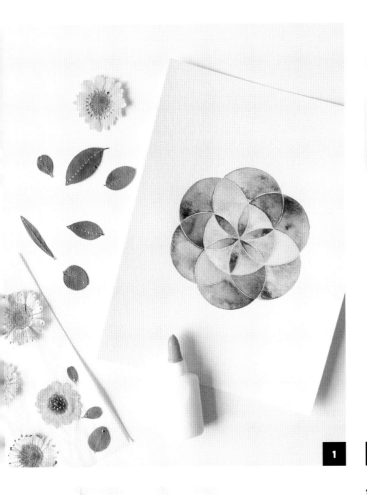

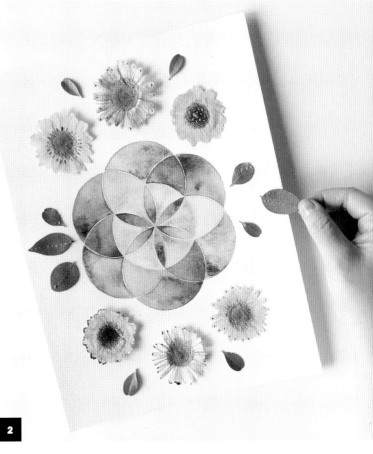

WHAT YOU'LL NEED

Seed of Life watercolor painting

Embellished pressed flowers and leaves

Glue

Paintbrush

1 Make sure all paint is completely dry before you begin.

2 This is the best part! Begin to play with the botanicals, intuitively arranging them in a symmetrical style around your Seed of Life painting. Don't take this too seriously; you have all the time in the world to arrange and rearrange. You're only placing the elements at this point; there's no glue involved yet. The way you arrange the flowers and leaves will depend on the size, shape, and amount of space you have to work with.

3 You can also integrate other mixed media to decorate your painting. I picked up a few stars I used in the constellation project on page 74 and decided they would look nice filling in some small empty areas on the page.

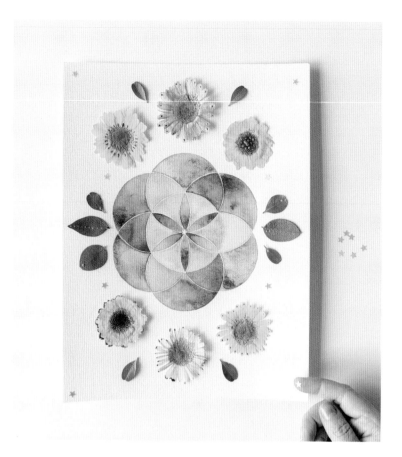

4 Once you're satisfied with your design and all the elements are in place, secure them to the paper with glue. I like watering down a bit of glue in a small dish. This makes the adhesive easier to work with and your botanicals will lay flat on the paper.

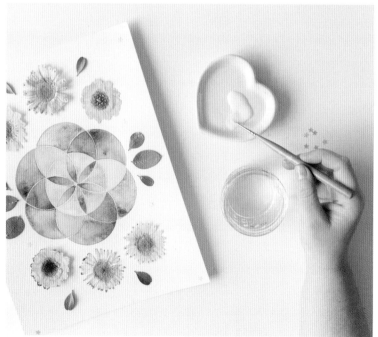

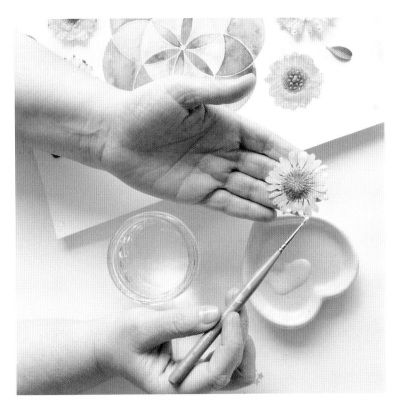

5 Gently holding each flower or leaf, add a small amount of adhesive. Make sure to get the tips!

6 One by one, gently secure the botanicals to the paper. You can do this by pressing down with dry hands or using the other end of your paintbrush.

Once everything is glued to the painting, you have a complete mixed-media masterpiece on your hands! I recommend glass-framing a piece like this—this much work deserves it, plus your pressed flowers will stay in place perfectly.

TEMPLATES

Here are some simple outline drawings at a larger scale. Feel free to use these drawings as a reference point or guide for your own drawings. I recommend drawing your own versions instead of tracing for two reasons: It's a great way to practice observation and drawing technique, plus your artwork will have your personal touch. I always encourage embracing your own natural drawing style and continuing to practice until you feel like you have something special to call your own. This is an important element to creating a personal artistic style!

Moon Phases / Line Drawings

See page 71

Moon Phases / Black and White

See page 71

TOP

TOP

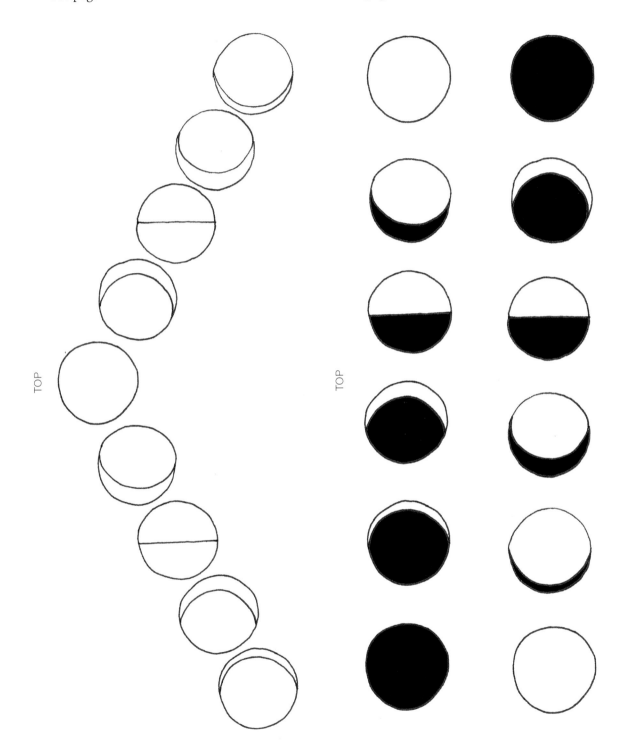

Constellations

See page 75

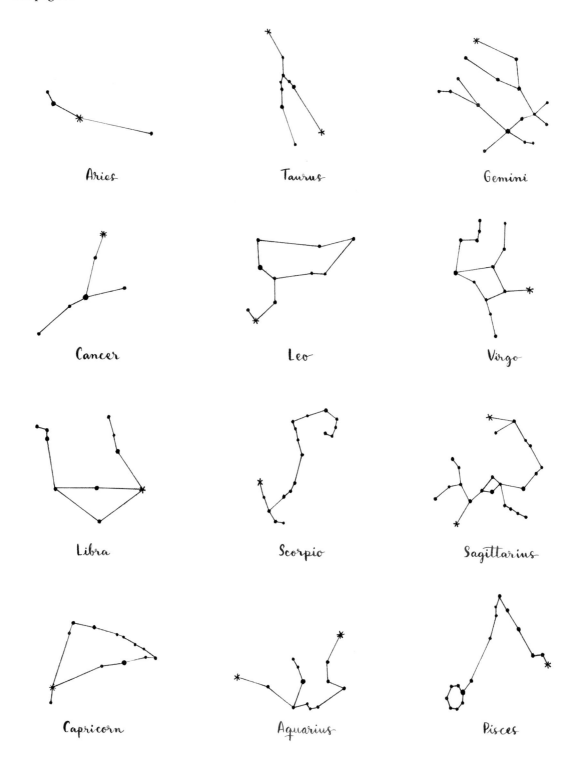

Aries

Taurus

Gemini

Cancer

Leo

Virgo

Libra

Scorpio

Sagittarius

Capricorn

Aquarius

Pisces

Amethyst Cluster

See page 92

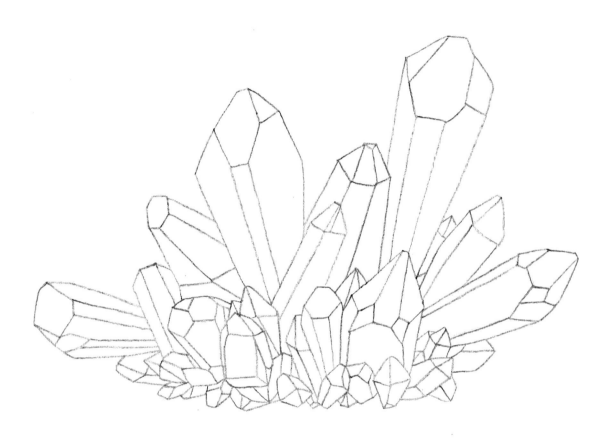

Loose & Experimental Healing Crystals

See page 100

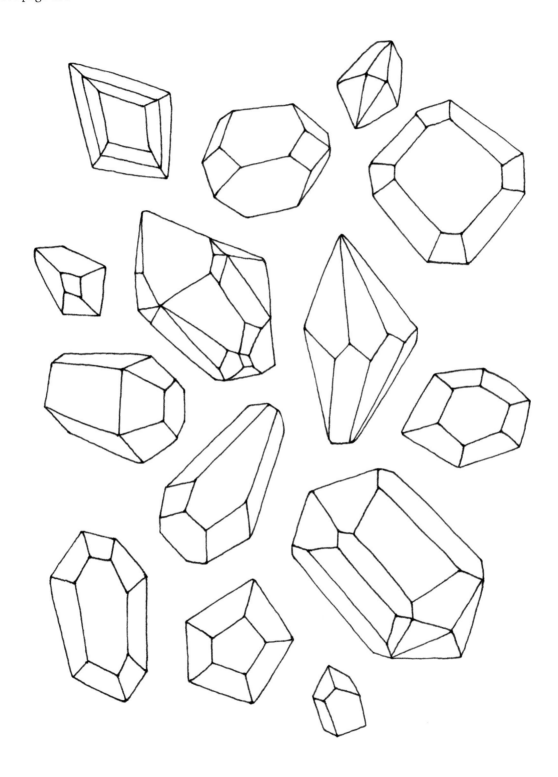

Birthstone Chart

See page 106

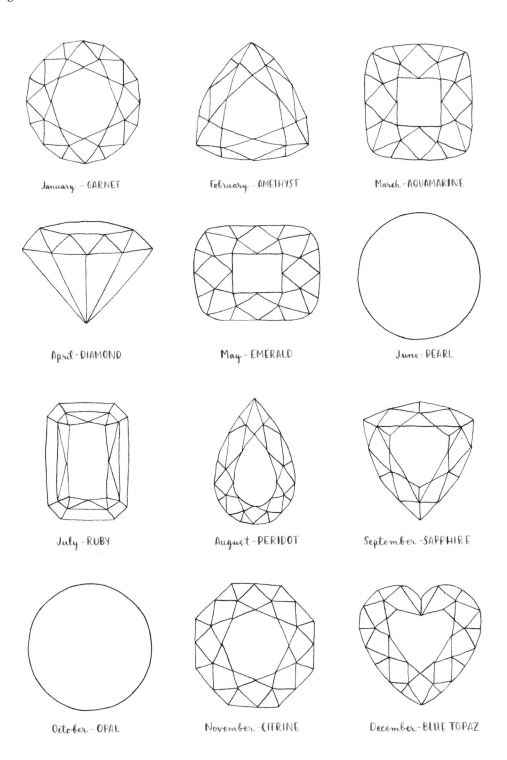

January – GARNET

February – AMETHYST

March – AQUAMARINE

April – DIAMOND

May – EMERALD

June – PEARL

July – RUBY

August – PERIDOT

September – SAPPHIRE

October – OPAL

November – CITRINE

December – BLUE TOPAZ

RESOURCES/REFERENCES

For further watercolor instructions I highly recommend taking my online courses with Skillshare and Domestika.

www.skillshare.com/r/user/anavictoriana

www.domestika.org/es/anavictoriana

If you would like to continue your artistic journey and attend in person workshops and retreats, please visit:

www.anavictoria.com/learn

For more information on supplies used in this book:

Canson

www.canson.com

Copic

www.copic.jp/en

Dr Ph Martin's

www.docmartins.com

Holbein

www.holbeinartistmaterials.com

Hydracolour

www.etsy.com/shop/HydraColour

Kremer Pigmente

shop.kremerpigments.com

Legion Paper

www.legionpaper.com/stonehenge

Princeton

www.princetonbrush.com

Sennelier

www.sennelier-colors.com

Daniel Smith

www.danielsmith.com

Winsor and Newton

www.winsornewton.com

ACKNOWLEDGMENTS

First and foremost I would like to thank the incredible team at Quarto for showing interest in my art and continuing to believe in me and my work for the past several years. It's amazing to think that we are now on book number 3! Before I wrote my first book *Creative Watercolor* back in 2018, I had no idea how much hard work it takes to put this information out into the world! I mean, I had some idea, but actually participating in it gave me a total change of perspective. Not only by the author, but the dedicated team behind the publisher and co-editors in different countries from around the world. I am honored to be a part of this collaboration. Writing books has allowed me to share my love for watercolor with more people than I could have ever imagined!

I would also like to acknowledge my thousands of dedicated students who are on a path of learning and self-discovery, as I am.

To my parents, sister, husband, friends, extended family, teachers, and collaborators: I have felt nothing but support from you my entire life. To Betsy, for always believing in me and offering guidance, friendship, and wisdom along the way.

I am eternally grateful to be able to make and share my art with this beautiful global community. Thank you, thank you, thank you.

ABOUT THE AUTHOR

The author of *Creative Watercolor, Color Harmony for Artists,* and *Creative Watercolor and Mixed Media,* **Ana Victoria Calderón** is a visionary watercolor artist and teacher with a bachelor's degree in information design and continued studies in fine arts. Her licensed artwork can be seen in retail outlets throughout the United States and Europe on a wide variety of products. Ana teaches in-person workshops and hosts creative retreats in Tulum, Mexico, as well as summer watercolor retreats throughout Europe and central Mexico. She has taught over 200,000 students on Skillshare, where she is a Top Teacher, and Domestika combined. See more of Ana's work on Instagram (@anavictoriana), YouTube (Ana Victoria Calderon), and Facebook (Ana Victoria Calderón Illustration). Ana is based in Mexico City.

INDEX